I M A G E S

of Modern America

OHIO'S CANAL COUNTRY WINERIES

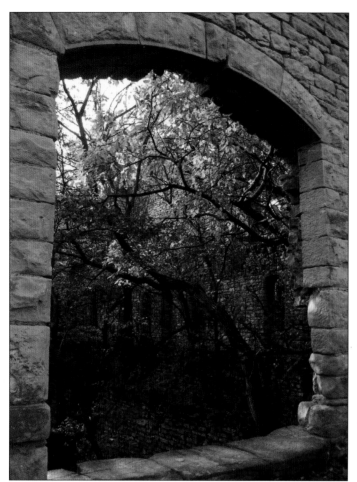

In the 1800s, the Ohio and Erie Canal opened the state of Ohio to further settlement and the emergence of significant agricultural and industrial developments. The influence of the canal that ran alongside the rivers is still felt today. Against this background, farms and towns were born, with some of the farmland eventually devoted to vineyards. This window at the historic Kelley's Island Winery shows the deep historic roots of Ohio's wineries. (Author's collection.)

ON THE FRONT COVER: Clockwise from top left:
Dalton "Duke" Bixler, cofounder of Breitenbach Cellars, barrel samples wine (courtesy of Breitenbach Cellars), the vineyards at Breitenbach Cellars grow tall and robust in the heart of Ohio's Amish Country (courtesy of Breitenbach Cellars), a restored canal boat on the Ohio and Erie Canal in Coshocton (courtesy of Ernest Mettendorf), Rainbow Hills Vineyards (courtesy of Coshocton County Convention and Visitors Bureau), the 1886 schoolhouse at School House Winery (courtesy of Paul Taller).

ON THE BACK COVER: Clockwise from top left:
The Debevc family at Debonne Vineyards, the largest estate winery in Ohio (courtesy of Chalet Debonne Vineyards), a Civil War–era dairy barn at Perennial Vineyards (courtesy of Perennial Vineyards), bottles of Vidal Blanc, Chardonel, and a Noret and Chardonel blend wine at Raven's Glenn (courtesy of Raven's Glenn Winery).

IMAGES
of Modern America

OHIO'S CANAL COUNTRY WINERIES

Claudia J. Taller

ARCADIA
PUBLISHING

Published by Arcadia Publishing
Charleston, South Carolina

Printed in the United States of America

Library of Congress Control Number: 2015932620

For all general information, please contact Arcadia Publishing:
Telephone 843-853-2070
Fax 843-853-0044
E-mail sales@arcadiapublishing.com
For customer service and orders:
Toll-Free 1-888-313-2665

Visit us on the Internet at www.arcadiapublishing.com

This book is devoted to the vineyard and bee keepers, the winery owners and their crews, and to the winemakers who make grapes and juice into wine that gladdens the heart. Wineries require hours of dedication, face challenges of weather whims and inconsistent juice, and host tasting rooms that ebb and flow with patrons. The making of a winery requires a big heart and an open attitude.

CONTENTS

Acknowledgments 6

Introduction 7

1 Western Reserve and Lake Erie's Shore History 9

2. The Cuyahoga Valley 17

3. Foothills of the Appalachians 29

4. Stark County Canal Towns 45

5. The Lake District 57

6. Three Rivers Wine Trail 67

7. Farm Country 77

8. Canal Country Wineries Then and Now 91

Your Guide to Canal Country Wineries 94

ACKNOWLEDGMENTS

The wineries of the Canal Country region of Ohio have been generous with their time and their photographs. I also acknowledge the work of the organizations that make sure our Ohio wineries continue to grow in number and the development of their craft: the Ohio Agricultural Research Development Center, the Ohio Wine Producers Association, the Ohio Grape Industries Committee, Pairings—Ohio's Wine & Culinary Center, the Lake Erie Enology Research Center, and Kent State's VESTA Program at its Ashtabula Branch. The research I did while working on my first wineries book in 2010 has served them well—I thank the wine makers who taught me about grape varieties, planting, trimming, grafting, the crush and fermentation processes, and what makes a good wine. In addition, I thank the Cuyahoga Valley National Park and the various historical societies that allowed me to use their photographs. My husband, Paul, often accompanies me with his camera on winery country excursions, and his patient support has been essential to this work.

INTRODUCTION

Ohio's Canal Country Wineries captures the spirit of those who lived off the land from Cleveland to New Philadelphia, along the Cuyahoga River and down to the Muskingum River, the path that the Ohio and Erie Canal took when it was built in the 1820s and 1830s. Back then, the rich and fertile farmland was not used for wine grapes, for time and resources were too limited for a product as frivolous as wine in the mid-1800s. It was not until the late 20th century that farmers began to turn land over to viticulturists hoping to create a new wine region in Ohio.

Historically, the Colony of Connecticut claimed the northeastern region of Ohio, a 120-mile-wide strip that encompassed the area between Lake Erie and a line south of Youngstown and Akron, until the land holdings were sold to the Connecticut Land Company. Moses Cleaveland arrived at the mouth of the Cuyahoga River to survey the land and divide it into townships in 1796, and the City of Cleveland was founded. In 1800, Connecticut ceded sovereignty over the Western Reserve.

It was difficult to purchase supplies or sell products in a road-less landscape. The building of the canal south from Cleveland was an expensive proposition fraught with many risks. But visionaries saw it as a water route via the Ohio and Mississippi Rivers that would take barges from the Great Lakes to the Gulf of Mexico. Stories of working the canal and the places along the way are colorful reminders of how remote the Western Reserve was in the early 19th century.

While the canal was being built, European settlers who settled along Ohio's lakeshore and islands discovered how well grapes grew with the moderating effect of Lake Erie's climate. The large body of water keeps the area along the lakeshore warm into the fall, allowing grapes to fully mature before the first frost. The Lake Erie Appellation (wine region) has the longest growing season in the northern United States, and Ohio, or "Vinland" as it was called in the mid-1800s, was the premier wine-producing state until folks started planting vineyards in California.

Once the railroads were built, and once entrepreneurs understood the efficiency of train travel, the canal was no longer useful, but the villages and towns, with their millworks and granaries and quarries and the products they made, remained. Today, the seasonal waterway encrusted with lock ruins and stone passageways is preserved in an area of beautiful scenery and rich history, an area dotted with some of Ohio's most charming wineries.

The Ohio Wine Producers Association has defined the Ohio wine-touring area south and east of the Lake Erie Appellation as canal country. Many of the local farms disappeared in the latter part of the 20th century, but recent financially intense years have caused people to reassess their relationship with the earth. Today, earth's bounty is found in local honey, fresh goat's milk, vegetables grown year-round, orchards, and local wine. Several dozen wineries in

canal country show off the entrepreneurial spirit of the area's forebears and take advantage of fertile farmland. Road-trip visitors will also find antique stores, art galleries, gardens, farmers' markets, and historical sites as they travel through the countryside.

Come along, learn about the wineries in the Cuyahoga Valley region, down into Akron and Canton, east to a region of lakes, south to Amish country and canal villages like Zoar and Roscoe, then northwest into the farmlands that stretch for miles. The wineries are widely spaced out, all of them having sought just the right microclimate and soil in which to plant grapes that become good wine.

One

Western Reserve and Lake Erie's Shore History

To think of a landscape in terms of its history brings deeper meaning to the experience of touring wineries. Before DeWitt Clinton's crazy dream of a canal was realized, inadequate transportation made it difficult for farms, mills, and artisans south of Cleveland to successfully trade goods in large markets. Even before that, original peoples used the Crooked River ("Cuyahoga" in an Iroquois language) for passage through the Cuyahoga Valley, where today their ancient spiritual presence can be felt. Visitors to the Cuyahoga Valley National Park, one of the busiest national parks in the United States, marvel at the rocky remains of the old canal along the Ohio and Erie Canalway Towpath Trail, an American Scenic Byway.

In *Ohio's Lake Erie Wineries*, the author explored the wineries along Lake Erie's shoreline and islands from the mid-1800s through today. When Ohio was known as Vinland, most of the wineries were along the Ohio River, until mildew and mold killed all the grapes and the winemaking industry moved to Lake Erie's shore. It is impossible to tell the story of the canal country wineries without touching on the importance of the Lake Erie Appellation. By the 1830s, about the time that the canal was completed, Lake Erie's shores and islands had been settled by European settlers. Germanic sweet wines pressed from native varietals were what Ohio winemaking became known for.

In the 1960s, winemaking in Ohio took a dramatic turn when winemaker Arnie Esterer of Markko Winery in Conneaut started experimenting with European varietals and French-American hybrids, including Chambourcin, Vidal Blanc, and Seyval. Property owners with family farms followed suit and Chardonnays and Cabernets became as common as Concords along the lakeshore. Meanwhile, out on the islands, Lonz Winery on Middle Bass Island and Heineman's Winery on South Bass Island continued to serve up sweet pink Catawba to vacationers who preferred the sweet wines. Today, award-winning Pinot Noirs from St. Joseph Vineyards east of Cleveland share the stage with Quarry Hill Winery west of Cleveland and historic Mon Ami Winery near the islands.

The canal country wineries that took root in the late 20th century were inspired by the Lake Erie region, where, by 2014, over 50 wineries ranged from the Indiana border to the Pennsylvania border. It is against the backdrop of canals in the Western Reserve and Ohio's burgeoning wine industry that this book rambles down the road to explore the canal country wineries.

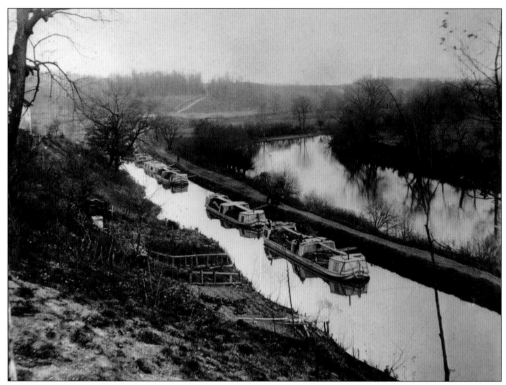

In the 1800s, the Ohio and Erie Canal helped open the state to settlement, then led the way to the emergence of significant agricultural and industrial developments that influence the state of Ohio to the present day. This photograph of canal boats was taken near Everett, about 37 miles north of Massillon, in the Cuyahoga Valley. Alanson Swan owned horses in small-town Everett, but the business failed by the 1870s as canal traffic declined. The National Park Service bought much of Everett to create the Cuyahoga Valley National Park. (Courtesy of Portage Lakes Historical Society.)

Improvements in transportation in the 19th century allowed Cuyahoga Valley farmers to take advantage of markets in Cleveland and Akron. Before the canal was completed, farmers took their produce by wagon to the mouth of the Cuyahoga River to be shipped to larger markets, an arduous path across rudimentary bridges and through wilderness. The Trapp Family Farm is a small sustainable-practices farm in partnership with the Countryside Conservancy. (Courtesy of Cuyahoga Valley National Park, Dave Williams.)

From the 1840s onward, many regional farmers traveled to Cleveland's West Side Market, Central Market (later the New Central Market), and the Sheriff's Street Market. West Side Market opened in 1912. The corridor between Cleveland and Akron, where the farmers' market operated on Beaver Street from the 1920s through the 1970s, emerged when it opened. The West Side Market looked then much as it does today. (Courtesy of Scott David.)

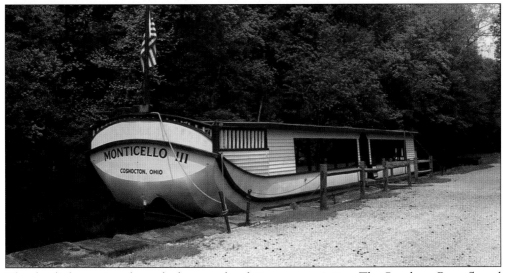

Cleveland's farmers' markets relied on canal and river transportation. The Cuyahoga River flowed up to Lake Erie, but to go downriver, the intense and complicated lock system moved canal boats along, stopping at places such as the farmers' market in Akron. The first boat, the *Monticello* (pictured on the cover), arrived at Coshocton from Cleveland in 1830. Even after the canals were built, corn and wheat crops and fruit could spoil before they reached their destination. (Courtesy of Coshocton Lake Park.)

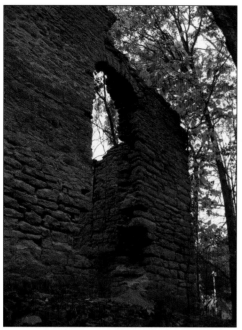

Meanwhile, Nicholas Longworth planted 1,200 acres of Catawba grapes along the Ohio River. He boosted Ohio to the largest producer of wine in the United States by 1859. Tragically, Longworth's vineyards were ravaged by black rot and mildew by 1860. Some Southern Ohio vintners regrew their vineyards on the north coast, while others moved to the Lake Erie shore and islands, such as Kelly's Island Wine Company, which is now in ruins. (Author's collection.)

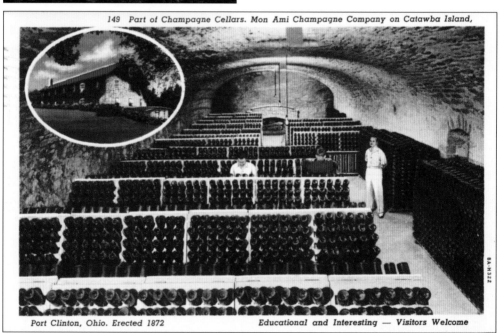

149 Part of Champagne Cellars. Mon Ami Champagne Company on Catawba Island,

Port Clinton, Ohio. Erected 1872 Educational and Interesting — Visitors Welcome

In 1830, Clevelander H.C. Coit predicted the Lake Erie region would become world famous. Grape growers promoted Catawba vineyards, later dominated by Concord vineyards east of Cleveland. Wineries included Dover Bay Grape Wine Company, Lake View Wine Farm, and Louis Harris Winery. In 1869, John G. Dorn founded a winery in Sandusky that was outfitted with oak casks from Longworth's wine cellar. Those who settled on the islands included the Rheinstrom brothers, Michael Werk, Joseph Peebles, and Philip Vroman. Cooperatives such as Catawba Island Wine Company (today's Mon Ami, pictured here) bridged the small producer/large producer gap. (Courtesy of R.B. Hayes Presidential Center, Frohman Collection.)

Luscious, wine-laden grapes flourish on Middle Bass Isle, where Lonz juices are produced. It's "home" for us.

Heineman's Winery on South Bass Island has been in continuous operation since 1888. Around 1900, Put-in-Bay was bustling, with 23 wineries on South Bass Island. During Prohibition, the winery stayed open by offering tours of its crystal cave and tributaries. Others, like nearby Lonz Winery on Middle Bass Island, sold juice with instructions on how not to ferment the grapes, which led to more wine being consumed during Prohibition than before it began. (Courtesy of R.B. Hayes Presidential Center, Frohman Collection.)

Prohibition destroyed the wine industry in Ohio, but the farms along Lake Erie's moderate shore continued to grow grapes that were often sold at Welch's depots constructed along the train route from Erie to Toledo. Many vineyards sold their juice with sly instructions on how to prevent the wine from fermenting. After Prohibition, city dwellers brought local wines to their restaurants by bottling their own wine made from local juice or brought in from family vineyards such as Avon Lake's Klingshirn Winery. (Courtesy of Klingshirn Winery.)

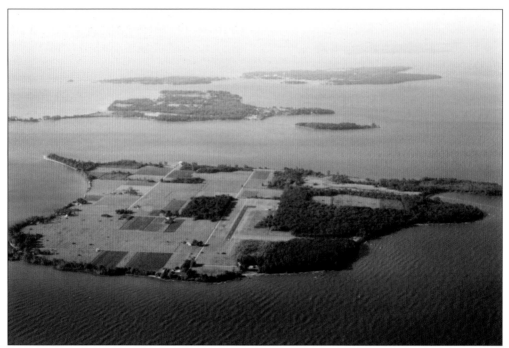

Meanwhile, out on the Islands, Lonz Winery on Middle Bass Island and Heineman's on Put-in-Bay continued to serve up sweet pink Catawba to vacationers who preferred the sweet island wines. Today, award-winning Pinot Noirs from St. Joseph Vineyards east of Cleveland share the stage with Quarry Hill Winery west of Cleveland and historic Mon Ami Winery near the Islands. Many Lake Erie wines are grown on North Bass Island, also known as Isle St. George, where Firelands Winery, one of the area's largest wineries, grows its grapes. (Courtesy of Firelands Winery.)

One of Ohio's later pioneers of the wine industry is Conneaut's Arnie Esterer, who planted an experimental vineyard in 1968 and is a regional leader in growing vinifera, or European-style grapes. He taught many Ohio winemakers how to successfully grow and craft well-rounded European varietals and French-American hybrid wines. His influence on both the Lake Erie region and the canal-area wineries is indisputable. The winemakers and growers, when Markko Vineyards is mentioned, are quick to tell stories of Esterer's big heart for teaching. (Author's collection.)

Property owners with family farms started growing grapes and establishing wineries. East of Cleveland, Tony Debevc and his family opened Debonne Vineyards in 1972. It has become one of the most popular wineries in the Lake Erie region, and its vineyards are sourced by wineries throughout the state. Like the Debevc family, which had been growing grapes for decades, other family farms planted native grapes such as the prolific Concord, the pink Catawba, and the ubiquitous Niagara, and incorporated French-American hybrids, mostly engineered at Cornell University, and European viniferas. (Courtesy of Debevc family.)

Community gardens and even vineyards are sprouting up in Cleveland, a tribute to the gardens of places like Dunham Tavern Museum, once a stagecoach stop on the Buffalo-Cleveland-Detroit post road. The oldest building still standing on its original site in the city of Cleveland was built in 1824 by Rufus and Jane Pratt Dunham. Its gardens offer a glimpse of history and insight into the lifestyles of early Ohio settlers and travelers. Modern-day community gardens often look like the cooperative endeavor of the Countryside Initiative. (Courtesy of Cuyahoga Valley National Park.)

North of the national park, in Cleveland's inner city, Chateau Hough is located in an area well known for race riots during the 1960s and 1970s, but businessman Mansfield Frazier has reclaimed vacant land where houses used to stand for vineyards and uses them as training grounds for former prison inmates who need job skills. (Courtesy of Chateau Hough.)

The Cuyahoga Valley Railroad wraps around the crooked river just like the canal that followed its path before the dawn of the Industrial Age. Today, the railroad is used for passengers, who sometimes bring their bikes aboard, to move more quickly along the Ohio and Erie Canal Towpath Trail. Visitors spy eagles nesting in the trees, but if they are quiet, they feel the presence of the original peoples, whose spirits reside in the sacred valley. (Courtesy of Cuyahoga Valley National Park.)

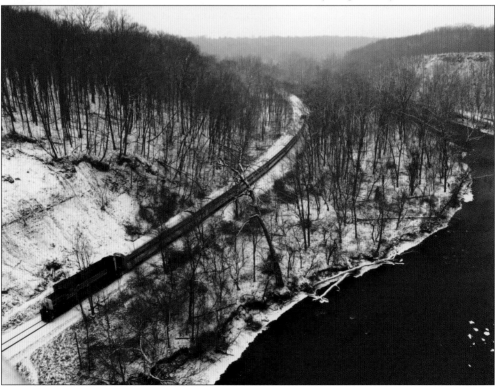

Two

THE CUYAHOGA VALLEY

The Cuyahoga Valley, carved by the passage of the great crooked river that loops around toward Lake Erie from Akron and begins north of there at Hamden Township in Geauga County, was once home to Native Americans and early settlers. Farms dotted the landscape along the Cuyahoga as it wound down to Akron. When the canal opened between Cleveland and Akron, a whole new world of customers became available, not only to the farmers but the mills and other businesses along the Cuyahoga River. Subsistence farming gave way to cash-crop farming, and milling, quarrying, and masonry soon became profitable industries.

In 1880, the Cleveland Terminal & Valley Railroad, which eventually became the Baltimore & Ohio Railroad, was built parallel to the banks of the Cuyahoga River and along the canal. Stations were built in Brecksville, Independence, Boston, Peninsula, Everett, Ira, and Botzum. The canal shipped wood and coal, but the valley farmers began to rely on the rail line.

Starting in the late 1990s, the National Park Service began rehabilitating historic farmsteads and leasing them to farmers who use sustainable practices. This program, the Countryside Initiative, helps preserve the agricultural landscape as well as sensitive natural and cultural resources. A new generation of farmers are buying farmland and putting it to good use. People want local non-engineered and chemical-free food and they want local wine. Farmers and vintners are responding.

Modern environmentally conscious farmers currently take advantage of the increasing popularity of farmers' markets and local wines, both in and outside of the Cuyahoga Valley. Farmers' markets offer exciting venues for farmers to exchange ideas and for customers to support local and healthy foods. Wineries provide a chance to refine palates, talk with the vintners about their craft, and relax with friends. On this winery tour, hike the Cuyahoga Valley, stop at Szalay's, shop on Main Street in Peninsula, and visit three wineries: Sarah's Vineyard, the Winery at Wolf Creek, and Red Horse Winery. The Cuyahoga Valley is where canal country and the Lake Erie Viticultural Area intersect.

One of the most significant natural landscapes in canal country is the Cuyahoga Valley. Frontiersmen Stephen and Mehitable Frazee, early Ohio settlers, purchased land along the Cuyahoga River in 1806. They built their brick house around the same time as construction of the Ohio and Erie Canal began. The canal gave farmers like Frazee access to the East's markets. The house has recently been renovated and can be visited. (Courtesy of Cuyahoga Valley National Park.)

Peninsula Village is tucked into the hills where the Cuyahoga River forms a peninsula. The eponymous town of Peninsula, just north of Sarah's Vineyard, is named for the land mass on which it sits, formed by the Cuyahoga River's meandering path. The town became known as Seaport Town, as it linked the Western Reserve to Atlantic Seaboard trade when the canal opened. The village had much of the same style as the Eastern seaports, with bars and hotels making it more cosmopolitan than other nearby canal towns. Stanford House, an example of a Peninsula home, is now renovated as a hostel. (Author's collection.)

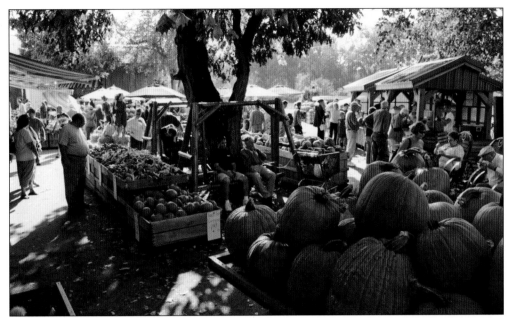

Szalay's Sweet Corn Farm has been a fixture in the Cuyahoga Valley since 1931, when John "Big Jim" Szalay moved to the area and began growing sweet corn. He started out with 67 acres and quickly increased it to 300 acres. Four generations later, Szalay's Farm has become a specialized sweet-corn farm and old-fashioned farm market that offers a wide variety of fresh produce. (Courtesy of Cuyahoga Valley National Park.)

For a real experience of life on the canal, visit Hale Farm, which was built by Connecticut native Jonathan Hale and his sons in the 1820s and passed down to his son Andrew Hale, grandson C.O. Hale, and great-granddaughter Clara Belle Ritchie. Ritchie willed it to the Western Reserve Historical Society, which now operates a living history museum on the property. This farm is near present-day Sarah's Vineyard and part of the Countryside Conservancy. (Author's collection.)

Many of the old homesteads in the Cuyahoga Valley, including Goatfeathers Point Farm, Spicy Lamb Farm, Canal Corners Farm, and Spring Hill Farm, are part of the Countryside Conservancy. The animals, such as this goat, like the attention they get from visitors to the Cuyahoga Valley. This photograph was taken during a bike tour of Conservancy farms. (Author's collection.)

Farming has long been an occupation in the Cuyahoga Valley, beginning as early as 2,000 years ago with the prehistoric peoples. In the 19th and early 20th centuries, farming was the dominant way of life for most residents. Homesteads included the Vaughan Farmhouse near Jait's railroad crossing. The proximity of the railroad, and the canal before that, was important to the farmers, who subsisted and cultivated their products much like the Conservancy farmers do today. (Courtesy of Cuyahoga Valley National Park, Ted Toth.)

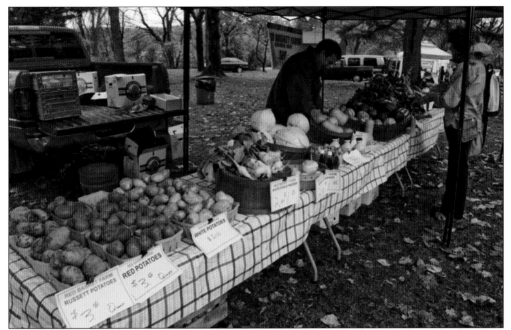

Countryside farmers' markets give local farmers the chance to sell their goods directly to consumers. The markets can be found at Howe Meadow in the warmer months and at Old Trail School during winter. Fun educational events include cheese making, bread making, fermentation, and exploring the small-farm dream. (Courtesy of Cuyahoga Valley National Park.)

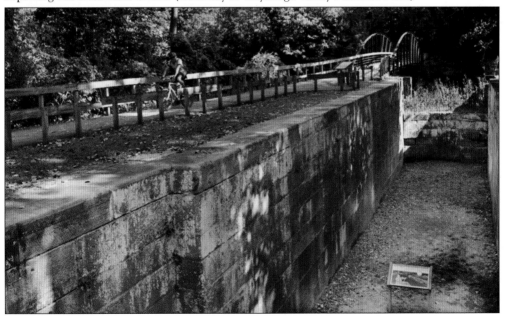

Hiking in the Cuyahoga Valley or sitting on one of the rocky ledges on the hills rising from it, one is reminded that Native Americans used the Cuyahoga River as a means to conduct trade long before Europeans began their explorations into the Western Reserve. Towpath signs describe the remnants of ancient cultures and early settlements. Bald eagles and blue herons fly above, to remind people that they were here earlier than man. (Courtesy of Cuyahoga Valley National Park, Tim Fenner.)

While the canal opened up trade routes, the new railroad (in use by 1852) quickly replaced canal boats, which could be delayed, overloaded, and slow. Farmers could more easily ship products and buy machinery transported by rail. The railroad and depot in Peninsula are symbols of the canal's demise and the promise of the future. The Cuyahoga Valley Railroad hosts family outings and wine tastings in its train cars. (Courtesy of Cuyahoga Valley National Park, Ted Toth.)

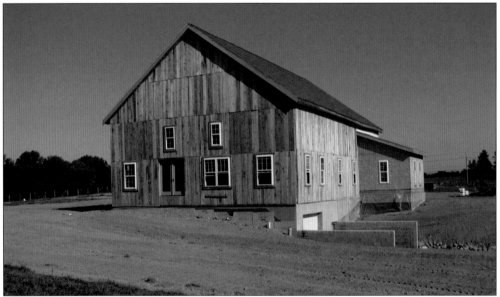

Mike Lyst always wanted to own a winery and had been making wine at home for 30 years before he submitted a proposal to lease property from the National Park Service. Sarah's Vineyard was established in 2001 by Mike and his wife, Margaret. It was built on land across the country road from Blossom Music Center. The pavilion fireplace was built with Old Berea curbstones from West Fourteenth Street in Cleveland. The winery building itself is partly constructed from 1854 hand-hewn wood recovered from property near Cloverleaf High School in Medina County. (Courtesy of Sarah's Vineyard.)

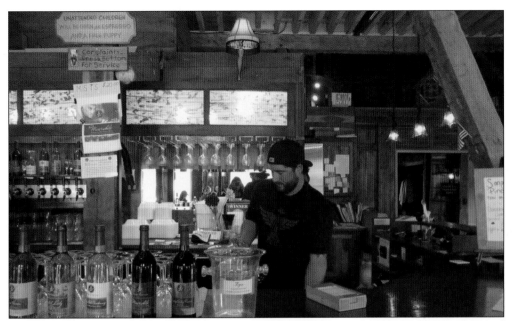

Sarah's Vineyard now grows Chambourcin, Niagara, Vidal, Seyval, Cayuga, Traminette, and Rubiana hybrid grapes. Its estate-bottled wine includes the Blue Heron Blush and Miserabile, the latter of which includes merlot, Sangiovese, and zinfandel sourced from other locations. Because Sarah's Vineyard pours wine from reconditioned beer kegs, with nitrogen to push the wine, the wines contain low amounts of sulfites. (Author's collection.)

When winemaker Mike Lyst visited Italy, he saw that many winemakers keep wine in casks and bottle it daily from the tap, a cheaper and greener way of selling wine, and when Lyst returned home, he incorporated Italian ways at Sarah's. Lyst feels that by operating the winery, he is giving back to the community, and says, "It's an attraction in the park, increases the funding it gets, and supports the park which gets a percentage of the profits." Sales of local art and food from the kitchen (including flatbread pizzas) help the bottom line. When there, try the red blend and the Riesling. (Courtesy of Sarah's Vineyard.)

This small-scale sustainable winery has three acres of grapes on a former hayfield. It has been leased for 60 years, and everything put into the soil must be approved by the National Park Service. The wineries of canal country, including Sarah's, are not protected by Lake Erie and must be careful what grapes they plant. (Courtesy of Sarah's Vineyard.)

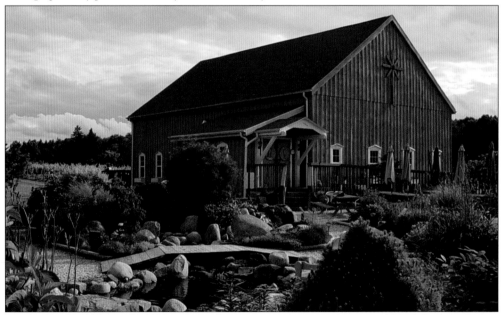

For the summer solstice festival, Mike and Margaret invite 14 wineries and local food producers, artists, and musicians, which attract 6,000 attendees. Gallery walls inside the winery show off the work of local and global artists, and fused glass adorns the wall behind the bar. Much of their wine is sold to Blossom Music Center visitors before outdoor Cleveland Orchestra concerts. (Courtesy of Sarah's Vineyard.)

After visiting Sarah's, head east to the Winery at Wolf Creek in nearby Norton which was established in 1980 by then-owner Andrew Wineberg. Wineberg began planting grapes on his family's property, and in 1984 he created the wine cellar by blasting out a hill—the tasting room and deck sit over it today. Andy Troutman was the vineyard manager before he and his wife, Deanna, bought the winery in 2002. The Troutmans also own Troutman Winery in Wooster, Ohio. (Courtesy of the Winery of Wolf Creek.)

Winemaker Carrie Bonvallet crafts native labrusca wines like Niagara, several hybrids such as Cabernet Franc, and European viniferas that include Chardonnay. The Norton Winery is known for its exceptional wines and the view of the creek down a green expanse of grass below the tasting room and outside deck. Grapes grown on the premises are used in 30 percent of the wine produced. (Courtesy of the Winery at Wolf Creek.)

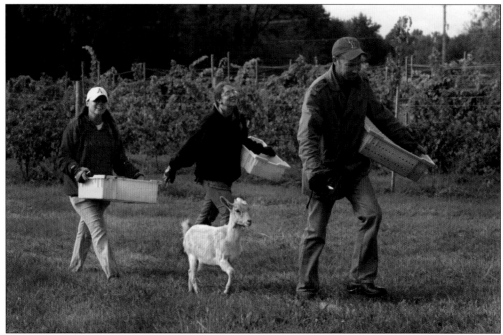

Andy and Deanna Troutman own Wolf Creek and Troutman Vineyards, but do not use grapes from Wolf Creek at Troutman and vice versa. They grow Leon Millot, Cabernet Franc, Pinot Gris, Vignoles, Riesling, and Isabella at Wolf Creek and uncork their Nouveau in November. Goats love their grapes. (Courtesy of the Winery at Wolf Creek.)

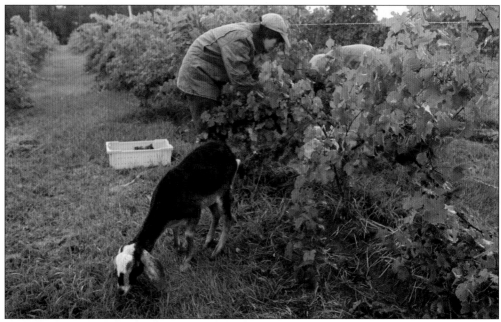

Wolf Creek enhances the winery experience with music, cooking classes, and yoga. Customers can bring in their own food from nearby restaurants and picnic outside or inside. The winery also serves several beers, cheese and crackers, chips, and chocolate. But perhaps the best time at Wolf Creek is working in the vineyards. (Courtesy of the Winery at Wolf Creek.)

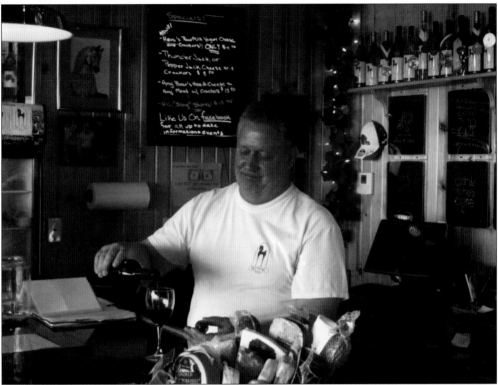

Joe Semansky Jr. presides at Red Horse Winery in Barberton. When Semansky planted his vineyards, he had been making wine as a hobby for quite some time while training horses. In 2004, Muscat was his first amateur winemaking gold-medal winner, and it went on to win many other competitions, which gave him the boost of confidence needed to pursue his dream. (Author's collection.)

Construction of Red Horse Winery started in 2007, and the winery opened on February 7, 2009. The first bottle of wine sold at the winery was G Spot, a Riesling wine enhanced with a bit of Granny Smith apple. The blackberry, Niagara, and pink Catawba are all medal winners. Joe Wine not only won a gold medal in the 2011 Ohio Wine competition, it also won the Ohio Quality Wine Award, which impressed some of the big-time winemakers in Ohio. (Courtesy of Red Horse Winery.)

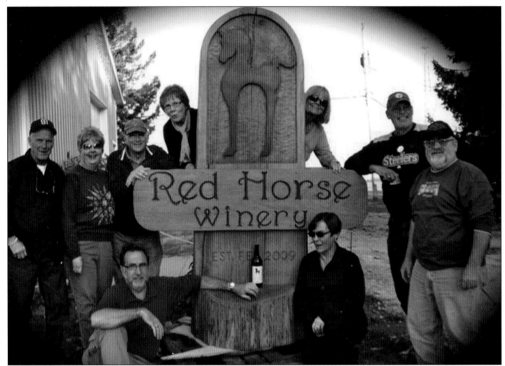

Semansky loves sharing his wines at Red Horse Winery because he is thrilled that he crafts great wines that people appreciate. He keeps everyone happy while they taste wine. The pleasant dining room commands vast views of fields looking off toward Cleveland, and food can be had from the food trucks outside. This is his crew. (Courtesy of Red Horse Winery.)

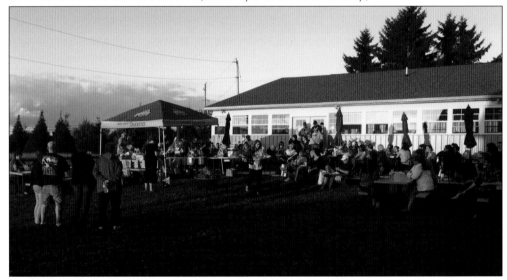

At the end of a festival day at Red Horse, with the sun low, relaxed revelers enjoy respite from their busy lives. If one wants to extend a visit in the Cuyahoga Valley, the most authentic choice is the Inn at Brandywine Falls, which overlooks Brandywine Waterfall, a 67-foot natural wonder in the Cuyahoga Valley National Park between Cleveland and Akron. The house was built in 1848 and is listed in the National Register of Historic Places. (Courtesy of Red Horse Winery.)

Three

FOOTHILLS OF
THE APPALACHIANS

The canal country wineries defy geographical unity, especially in this area below the Lake Erie region and into Akron. Akron is officially in the Appalachian foothills, unlike the Cleveland area wineries, which means the roads are winding and the land hilly. The wineries near Cuyahoga Valley National Park are in a trough of land between high hills, a land carved out by the river. But in Akron, the land winds up and down, and the few lakes or rivers (like Wolf Creek) provide moderating qualities that enhance grape growing.

Many of the wineries on the lower Cuyahoga focus on home winemaking, honey wine or mead, and wines made from juice brought in from elsewhere. Wineries source juice differently. Some grow their own grapes and make their own wine and do not use other grapes for estate-grown and made wine. Some get portions of their grapes or juice from other places so they can offer a variety of wines to their customers. The labels tell the story—wine can be estate wine and can also be from an official region like the Lake Erie AVA. If the labels says Erie, the grapes were grown in the Lake Erie region, but the label could say "Ohio" or "American," depending on the source of the grapes.

Some use only this year's vintage and some mix vintages together to improve uniformity. Again, the label tells the story—if the juice is from a particular year, the year will be noted. If the juice has been mixed with wine from other years, the label will not include a vintage year.

The wineries in this region are in Akron and Mogadore, east to Kent and Brimfield, and north to Aurora, east to Garrettsville, and over to Cortland and Parkman on the eastern boundary. Culture abounds—the Akron Art Museum, the Kent State University Fashion Museum, and Stan Hywet Hall are all worth a visit. This tour, if one chooses to do it, will take a couple or several days, but while one experiences the many personalities of the wineries in this area, there is also a noticeable range in winemaking philosophies.

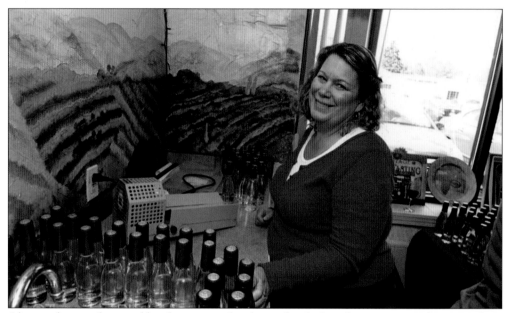

Akron is known for its rubber factories and industry, but before that, it was another stop along the canal. Places like Mustill's Store at Lock 15 became favorite stops for canal boaters. In one of Akron's commercial districts, the Grape and Granary looks like a typical storefront, but it belies the pleasant Old-World tasting room and friendly service at this winery, where all wines are made from juice. (Courtesy of Grape and Granary.)

Jim and Mary Pastor established the winery in 1992. The choices are a little overwhelming at the winery established in honor of Mary's grandfather Leonardo Mazzarella, who immigrated to Canton, but the hostesses are patient. Customers can purchase previously bottled wine or make their own wine and wait four months for a handmade batch. There are also opportunities for crafting beer, tending cheese, and roasting coffee. In 2014, the Pastors added Ohio's first microdistillery—Renaissance Artisan Distillery—to their lineup. (Courtesy of Grape and Granary.)

Crafted Artisan Meadery in Mogadore, just outside Akron, is one of only a few meaderies in Ohio. Mead is often grouped with beer, although it is not brewed, it is fermented. Kent Waldeck has created a meadery that does not supplement honey wine with grape wine. He has been surprised by Crafted Artisan's popularity—the meadery's products are sold in major grocery retail chains throughout the region. Crafted Mead opened in 2012 after about 10 years of experimentation. (Author's collection.)

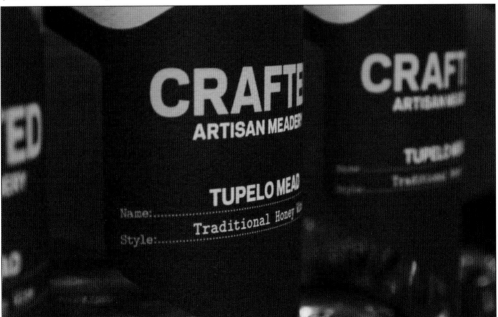

Waldeck won the Mazar Cup, a prestigious mead-maker reward for the world's oldest fermented drink, which dates back to 9,000 BCE in Asia. The meads at Crafted Artisan vary in alcohol content, from what one would expect in beer to the 12 percent typical of wine. Like grape wine, meads can be sweet or not so sweet, depending on how the mead is made. Offerings include Tupelo Dry from 100-percent Tupelo honey and a pinkish-colored blueberry honey wine. The meadery uses 45,000 pounds of honey in a typical year. (Courtesy of Crafted Artisan.)

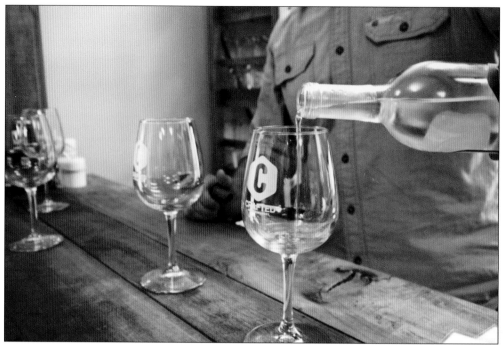

At Crafted Artisan, enjoy a glass of mead surrounded by the steel tanks and equipment against a background of warm wood. Pollinator is a semisweet, dry-hopped fizzy mead accented by blackberry. The Tupelo mead is made from Florida honey, and Blue Honey Melomel (mead made with fruit) is fermented with blueberries from Michigan. (Courtesy of Crafted Artisan.)

Viking Vineyards of Kent, just east of Mogadore on a country road, has a relaxing tasting room. Outside seating overlooks a lake; in fact, visitors approaches the winery on a causeway with water on each side. In 1997, Jeff and Dana Nelson left stressful corporate lives for a chance to share their love of wine and vineyards. They purchased the 20-acre property with a house and pole barn in 1998 and opened the winery in 1999 after consulting with the Ohio Agricultural Research Center. (Courtesy of Viking Vineyards.)

The Nelsons planted Vidal Blanc, Traminette, and Lemberger, and make wine with estate-grown grapes as well as juice sourced from other wineries. The award-winning winery also features Riesling, Cabernet Sauvignon, Vidal Blanc, and Chambourcin. Nordic Myst and Salmon Run are nice blends that show off winemaker Jeff Nelson's talents. Live music, painting classes, and girls' nights make visiting the winery an event. Inside walls are graced with original photography shot by Jeff, Dana, and their friend Jim Nelson. (Courtesy of Viking Vineyards.)

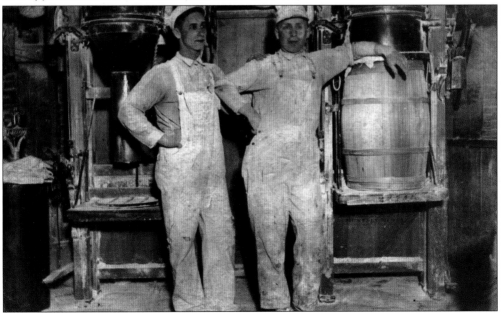

Kent is famous for its university, but was once the thriving industrial town on the Cuyahoga River known as Franklin Mills. The barrels in this photograph contain flour, not wine, and the two workers worked at Williams Bros. Flour Mill in Kent, still in operation as Star of the West. Star of the West Flour Mill is the only functional mill left in the city of Kent, once home to many mills. (Courtesy of Kent Historical Society.)

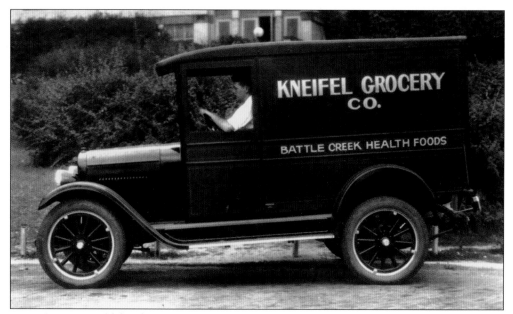

In 1905, Burt Kneifel, brother of Milton, bought out Charles Sawyer's interest in Kneifel's Grocery, to be known as Kneifel Brothers, and groceries were delivered by wagon and, eventually, by truck. Transportation along the canal took on many forms. (Courtesy of Kent Historical Society.)

East of Kent in Brimfield, Barrel Run Crossing Winery and Vineyard has been run as a family farm for four generations. The land has traditionally been planted with grain and soybeans, but the owners became passionate about the idea of owning a winery and growing grapes from trips to Sonoma and living in North Carolina. They planted the first vineyard in 2006 and now own 10 acres containing eight varieties of grapes. (Courtesy of Paul Taller.)

Barrel Run creates good wines, adds jobs in the area, and hosts space for the community to gather. After doing some test plantings, the viticulturists settled on disease-resistant and cold-hardy vines of French-American hybrids: Frontenac Gris, St. Pepin, Traminette, Vidal Blanc, Corot Noir, Frontenac, Marquette, and Noiret. To create exceptional blends, the winery augments its own estate-grown grapes with purchased Chardonnay, Viognier, and Cabernet Franc. (Courtesy of Paul Taller.)

North of Brimfield and Kent, in Aurora, the Tudor-style Dankorona Winery has been transformed into Thorncreek Winery. While Dankorona was in operation, winemaker George Danko produced, among others, Chardonnay, Seyval, Vidal, Riesling, White Knight, Vid-dare, Aurora Cream White, Aurora Cream Red, and Tudor Red. When David Thorn bought the winery, he put his artistic vision to work. (Courtesy of ThornCreek Winery.)

ThornCreek Winery and Gardens is the dream-come-true of David Thorn, an architectural environmental designer, who opened his winery in 2006. DTR Associates, Thorn's design firm located on the site, is recognized as a winery design firm. The beautifully landscaped winery may be the only one in Ohio with valet parking. The warm stucco walls of the indoor space and lighted brick terrace show off Thorn's love of plants and flowers. Garden herbs and vegetables are incorporated into the imaginative food selections at the winery. (Author's collection.)

Present-day ThornCreek Winery still produces some Dankorona-influenced sweeter wines. The winery's Cabernet Sauvignon and Riesling both won gold medals at the Ohio Wine Competition. The wines are made from the best grape juice available in Ohio and California. Although the dry reds are exceptionally good, its biggest seller is a sweet Niagara wine called Aurora Cream. ThornCreek's 11th wine—Pinot Noir—was added in 2014. (Author's collection.)

Directly east of Thorncreek at Tinkers Creek in Garrettsville, Candlelight Winery serves wine in a quaint candlelit tasting room. High school sweethearts Chris and Amanda Conkol began their winery journey when Chris discovered wine in Italy and studied winemaking at nearby Viking Vineyards and Portage Hills Winery. As a new winemaker, Chris Conkol started with a Chianti blend and then moved to Concord, Niagara, and Marechol Foch from juice. In his third year of winemaking, Chris used fresh grapes, and was hooked. He was making wine at home until his product overwhelmed them. The winery now also serves wine from Chambourcin, Bacco Noir, and Vidal Blanc grapes. These images show the two-story pole barn being built and Chris and Amanda at the grand opening celebration in 2004, near the time their twin daughters were born. (Both, courtesy of Candlelight Winery.)

The Conkols bought 15 acres of waterfront land and planted their first vineyards in 2000. While waiting for the grapes to mature, the couple took two years to hand build their winery. The tasting room opens up onto a deck overlooking a field and Tinkers Creek. The reflecting pond amongst acres of greenery creates an ambience that allows Candlelight Winery to stage live music with light food, including cheese plates and flatbreads, and a candlelight cove light show. (Courtesy of Paul Taller.)

In the far reaches of Portage County, one will find LaPorte Winery in Diamond, a place of cattails, black squirrels, chickens, and vineyards. The unique boutique winery crafts a nice variety of vinifera, hybrid, and native wines—the list of wines made by Joe LaPorte include Sangiovese, Pinot Noir, Malbec, Merlot, Concord, Rosette, Vidal/Seyval, Traminette, and Niagara. The vineyards are gorgeous and are the focal point of the property. (Courtesy of Paul Taller.)

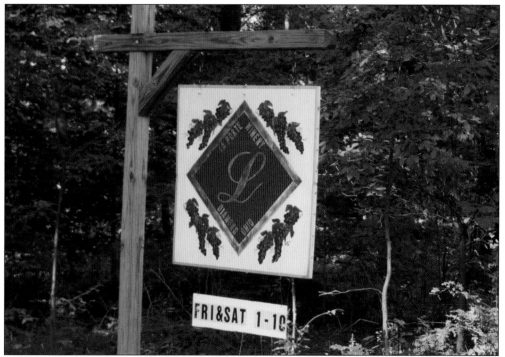

LaPorte is owned by Joe and Heide Laporte, who love to have people to their winery for potluck dinners, a real community affair. Stop in at the winery on a third-Saturday themed party night and be welcomed just as at a church potluck. Joe has been making wine for 20 years. (Both, courtesy of Paul Taller.)

In Dellroy, with a beautiful view of Atwater Lake, Al-Bi Winery Co. makes fruit and grape wines. The winery was founded in 2003 by Bill Burrow and Alan Rummell when Bill turned his 14-year hobby into a business. Alan and Bill bought new Italian winemaking equipment and purchased a wood-frame building on the main thoroughfare, showing off a natural-wood exterior and inside, a rough-sawed poplar tasting bar. They initially entered contests and won with their mostly sweet fruit wines. The winery also has some vinifera wines and a couple of hybrids, but its most popular is Foreplay, a blended red wine. Bill is happy with his elderberry, but is most proud of the Pinot. Bill believes the best picture of his winery is not of the winery itself, but the view of Atwater Lake. This image, however, captures the spirit of the winery. The Cabernet Franc has a nice peppery taste, the Merlot is very drinkable with its bit of blackberry, and the Bodacious Blackberry and Ramblin' Raspberry make great dessert wines. The winery bottles 12,000 to 15,000 bottles annually and sells wine wholesale. (Courtesy of Paul Taller.)

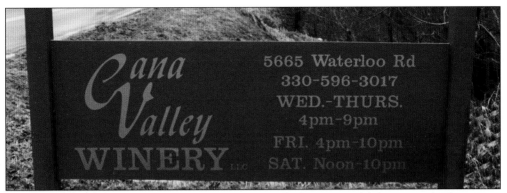

Also at Atwater Lake, Cana Valley Winery caters to the boating and fishing crowd. The winery shows off its fruit-flavored cherry Shiraz and peach Chardonnay, along with traditional Pinot Noir and Chardonnay. The updated barn on the former 40-acre horse farm helps visitors feel like they have gotten away to the country. The green apple Riesling, blueberry Merlot, and chocolate raspberry set them apart from other wineries. (Courtesy of Cana Valley Winery.)

At Cana Valley, one can watch sports on television or sit by the fireplace. Whatever the preferred method of relaxation, the 10-wine sampler may be the best way to experience what the wine cellar produces. Calvin and Esther Anderson and their son Calvin and his wife, Amber, are always on hand to answer questions. The winery began as a do-it-yourself winemaking experiment that turned into a full-blown business with the objective of producing sweeter varieties for new wine drinkers and drier noble-grape wines for experienced drinkers. (Courtesy of Cana Valley Winery.)

Twigg Winery in Mechanicstown is a cozy roadhouse where visitors can enjoy views of the valley from the patio, which is warmed by a fire in the colder temperatures of the Appalachian foothills. Situated in Carroll County, the winery is closer to the wineries in the Coshocton area than to other wineries in this chapter. Winemaker-owner Brent Baker planted his first vineyards in 1998, inspired by the nearby seven-generation family farm, Manfull Orchards, which produces apples for Twigg's hard cider and apple and peach wines. The vineyard now has a number of varieties of grapes, both vinifera and hybrid, which allows the winery to offer Cabernet Sauvignon, Cabernet Franc, Traminette, a semisweet Frontenac Rosé, Dornfelder, Edelweiss, Blaufrankish, and Vidal. To truly appreciate this winery's heritage and the vintner's talents, make sure to try their semidry apple wine. The winery was named after Jonathon Fox Twigg, a master gun builder specializing in dueling pistols and known for quality and consistency. Outbuildings on the property copied the Western Reserve–style farmhouse to emulate a small 19th-century tavern or inn. (Both, courtesy of Twigg Winery.)

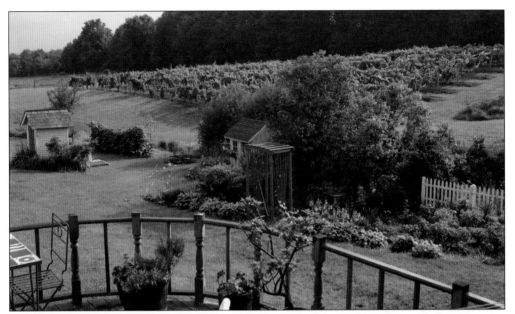

Richard Hill believes his winery should be a Lake Erie Appellation winery because of its proximity to the Grand River, but the winery is usually classified as a canal country winery. The winery was included in *Ohio's Lake Erie Wineries*. Richard and his wife, Betsy, named their winery for his grandmother Jeanne Marie Laleure Hill, a native of France's Loire Valley, who loved the gentle country life. (Courtesy of Laleure.)

The Hills purchased the Stoll dairy farm in 1997 and planted the first 250 vines that spring. Like many winemakers and grape growers in Ohio, they took classes at the OSU Agricultural School and Grape Extension and consulted with the Ohio Wine Growers Association. They initially planted Vignoles, Bianca, Chardonnay, and Pinot Noir and later added Riesling, Cabernet Franc, and Chambourcin. The Hills' daughter is pictured here receiving a marriage proposal from her betrothed in the vineyards, a place of joy and abundance. (Courtesy of Laleure.)

At Laleure, the wines are racked four to five times with little fining or filtering. All wines are made from estate-grown grapes, and the production room still feels very much like a dairy farm, even down to the floor troughs. While in the wide, open tasting room, sip an Ohio Pinot Noir ranked among the top in the state. The best place to spend the night is the Red Maple Inn in Burton, whose roots go back to 1798, when the Umberfield family arrived from Connecticut. (Courtesy of Laleure.)

Four

STARK COUNTY
CANAL TOWNS

South of Summit and Portage Counties, the vast farmlands of Ohio trail alongside the canalway. In 1828, the canal opened from Akron to Massillon, a distance of 65 miles. Canton and Massillon are known for their steel industry and football rivalries, but much of Stark County is farmland. At one time, Canton was the leading agricultural center of the country, known for manufacturing farm implements.

In recent years, vineyards have been planted in Stark County. Historically, the area was not home to vineyards, but rumor has it that the Poor Clares of Perpetual Adoration, who established their Canton home on the former John and Ida O'Dea estate in 1945, grew grapes for sacramental wine. Today, the wineries there consist of Gervasi Vineyards, Slutz & Slutz, Vino Fabbricanti, Meniru Meadery, Maize Valley, Newman Creek, and Perennial Vineyards. Each winery has a unique focus.

While in Stark County, stop at one of the many confectioneries: Harry London Chocolates, Waggoner Chocolates, Milk & Honey Candy and Nut Shoppe, and the Hartville Chocolate Factory. Do not miss the Hartville Flea Market. The Massillon Museum, the Canton Historical Society, and the Pro Football Hall of Fame top the cultural offerings during a visit to the area. Gervasi Vineyard & Italian Bistro's villa rooms are a natural choice for overnight accommodations. Not far from Gervasi, the Hoover Estate in Canton, named Fieldcrest, is also a good place to stay while touring the wineries of Stark County.

Gervasi Vineyard & Italian Bistro in Canton is within the city limits on 55 acres of property with five acres of vineyards. Originally a sawmill and then a tree farm, the original farmhouse and 1823 barn have become the manager's home and the upscale bistro. When Ted Swaldo purchased the property, he envisioned a small winery that served wine with cheese and crackers. The neglected barn became a candle-lit spacious dining room that serves pastas, steaks, and seafood with crisp salads and warm bread. (Courtesy of Gervasi Vineyard.)

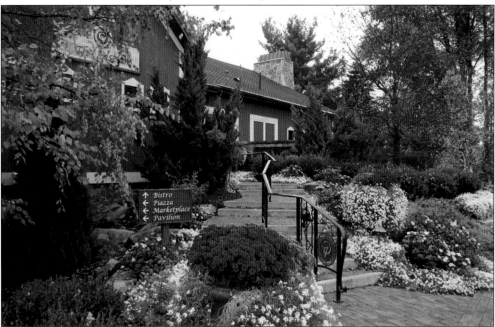

Gervasi Vineyards has grown into a Tuscan retreat. Scott Swaldo says the family-run operation expanded in response to customer demands. When people wanted a place to stay, Gervasi built the villas; when they wanted a place to hold weddings, Gervasi created the space; when they wanted festivals, Gervasi started hosting festivals and a weekly farmers' market; when they wanted to learn more about food and wine, Gervasi offered vineyard tours and culinary classes. (Courtesy of Dr. Charles Belles.)

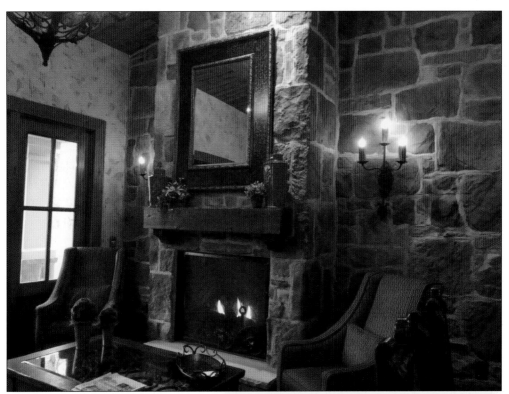

Outside, the bistro's patio is open during the warmer months for casual dining overlooking the six-acre lake, which is surrounded by walking paths that lead to Tuscan-style villas. The upscale rustic rooms feature high ceilings, stone floors, and dark-wood trim, and the bathrooms are outfitted with heated towel racks, dimmed lighting, high windows, and separated spaces. Breakfast, which arrives in wooden boxes, is served in common area living rooms, which open up to private patios. (Courtesy of Paul Taller.)

The Crush House allows guests to view the winemaking operations in a two-story urban space of chrome and red and interesting lighting. With the opening of the new Crush House, fans of the Gervasi winery find a new way to enjoy the wines crafted by winemaker Andrew Codispodi. (Courtesy of Paul Taller.)

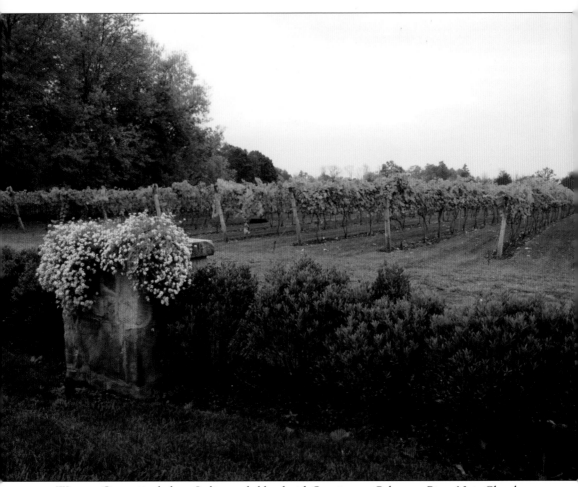

Wines at Gervasi include an Italian-style blend with Sangiovese, Cabernet, Pinot Noir, Chardonnay, late-harvest Riesling, Riesling, Pinot Grigio, and Vidal Blanc, with some wines made from estate-grown grapes and others from grapes sourced from the finest available. The vineyards can be seen from the villa patios and while walking near the lake. At Gervasi, people linger by the lake after two-hour meals and play bocci near the patio. The wait staff inquire about their customers' families. (Courtesy of Dr. Charles Belles.)

Vino Fabbricanti is a place where you can make and bottle your own wine. The winery offers over 50 different wine kits and all the supplies needed to do it, including the labels. Winemaking parties are a main attraction. The winery is owned by Ray and Diane Rovira, who source juice from all over the world, most of it from California, Australia, Italy, Chile, and Argentina. The red wines take about eight weeks, while the whites take four to six weeks from start to finish; until your own wine is ready, take home a bottle of Fabbricanti wine after sampling at the winery. (Both, courtesy of Vino Fabbricanti.)

Slutz & Slutz
Winery
"Nectar of the Gods"
Grown in Ohio
Concord
ALC. 12% BY VOL.

Also in Canton, Slutz & Slutz Winery believes in offering well-crafted wines in a modest tasting room. The winery was established around 2005. Virg and Nancy Slutz learned how to make wine from their German ancestors, who used presses to crush readily available Italian grapes. They planted a small vineyard of Niagara, Chambourcin, and Concord grapes, many of which are given away. Most of the purchased juice comes from the Lake Erie region, but the winery imports grapes from California and Chile for its dry wines. Winemaking is mostly a hobby for Virg, who is content drinking his wine (he loves his own Pinot Noir), but he makes around 1,000 gallons of wine a year. The winery hosts tastings, garden clubs, and weddings, and the most popular wine is the well-crafted Concord. Virg takes pride in his reputation as a fine winemaker. (Both, author's collection.)

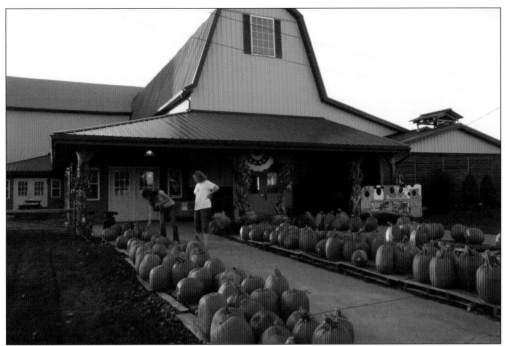

Maize Valley Market and Winery was inspired into being in 2004 when Michelle Bakan, her husband, Bill, and Kay, Donna, and Todd Vaughn (her parents and brother) decided to plant grapes in Marlboro Township, near Hartville. The land was granted to pioneer Joseph Vaughan and eventually ended up with great-great-grandson Kay Vaughn. The market and winery are housed in the beautifully restored 150-year-old barn with lots to do, including a 100-acre wagon ride, watching balloons lift off, petting animals, and navigating a corn maze. (Both, courtesy of Paul Taller.)

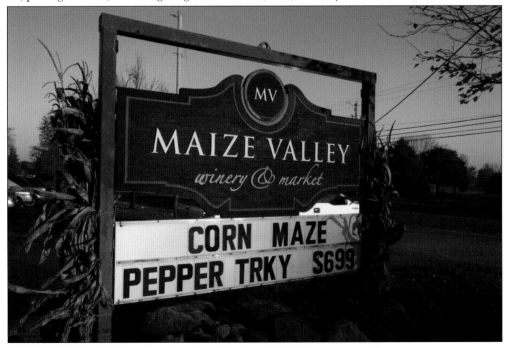

Maize Valley was planted with 3,000 acres of corn, wheat, and soybeans and used for grazing milking cows prior to 1997, when the Vaughns realized the potential of having a market. Wildflower gardens, fields, and vineyards can be viewed from a 200-seat pavilion. Vineyards include Chardonnay, Riesling, Traminette, Chambourcin, Concord, Vignoles, and New York 73 grapes. The winery sells 85 percent of its 15,000-gallon annual sales at the winery. (Courtesy of Paul Taller.)

Meniru Meadery is an ambitious Canton-area meadery. With production and demand for mead and hard cider on the rise, the Menirus decided to focus on the Old World spirits. Dr. Godwin I. Meniru is an obstetrician/gynecologist and Maryann O. Meniru is a counselor/adjunct professor, but at their meadery, they handcraft small-batch wines that can be tasted in flights, by the glass, or taken home. The tasting room is classically comfortable. (Courtesy of Paul Taller.)

Meniru honey wine is made using ancient recipes and modern techniques. Honey has a surprisingly broad spectrum of tastes, from very dry to dessert sweet, and because it can be fermented with fruits, herbs, spices, and grapes, the possibilities are endless. Fermentation varies from one week to several months. Like grape wines, the wine is fined to clear it, stabilized through filtration, aged for up to a year, and bottled. The fermented wines offered include apricot Pyment (mixed with Riesling), mead from orange blossom honey called Blossoms, spicy Flavorburst Metheglin, Ethiopian-style Tej, and hard cider. (Courtesy of Paul Taller.)

Newman Creek Cellars is located in a historic building in Massillon. King Arthur's Camelot is the winery's theme; the wines include Arthur's Favorite (Cabernet Sauvignon), Merlin's Magic (Merlot), Excalibur (Pinot Noir), Guinevere's Delight (Gewürztraminer), Gauntlet (Chenin Blanc), and Dragon's Lair (Riesling). The grapes come from as far away as the Napa Valley and South Africa. (Courtesy of Paul Taller.)

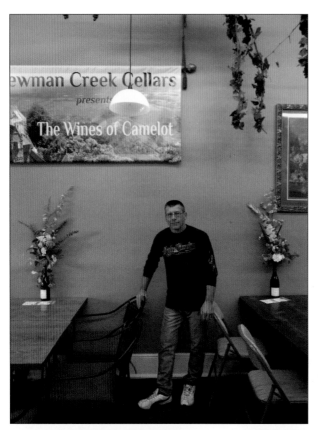

Newman Creek is primarily a winemaking facility, even though many choice wines can be tasted on the premises and taken home. Newman Creek carries many supplies for wine and beer enthusiasts, including Wine Expert and Brewer's Best kits. Newman Creek's local fan base keeps the winery lively and busy. (Courtesy of Paul Taller.)

Life on the canal in the Massillon-Navarre area meant many hours on the slow-moving boats. This photograph was taken around 1869. The Massillon Museum has a diverse collection of art and historical artifacts, as well as special exhibits, book discussions, author talks, and films. (Courtesy of Massillon Museum, Bennett Collection.)

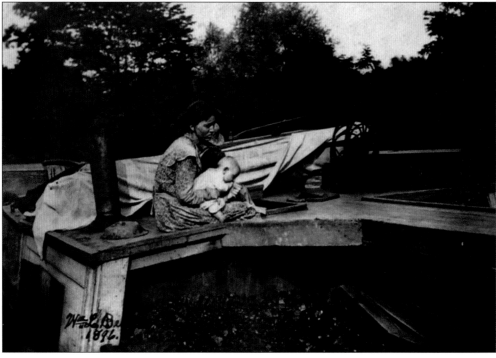

Although wine-making wasn't an industry in Massillon, some of the houses on Italy Hill above the canal were taverns that made and served wine. This photograph was taken in the mid-1800s, and is part of the 1869 Bennett Collection of the Massillon Museum. (Courtesy of Massillon Museum, Bennett Collection.)

Perennial Vineyards, just south of Massillon in Navarre, feels like being home on the farm. Away from the main roads, the winery is housed in a dairy barn whose exterior is much as it always has been, but inside, the cozy space has been warmed up with mahogany furniture, oriental rugs, and a large stone fireplace. All the grapes are handpicked. The ingredients for a wonderful time are all here: award-winning wines, gourmet pizzas, Old-World charm, wines for every palate, comfortable tasting room, and an outdoor pavilion. (Courtesy of Perennial Vineyards.)

The hand-painted Vidal Blanc and Our Flower bottles are a beautiful testament to the attention to detail the owners have given to the space and the wines made on the premises from estate-grown grapes. Damon and Kim Leeman founded the Navarre winery in 2002 and converted the white 1848 bank barn. Damon's family were always cheese makers, and he graduated with a degree in food sciences from Ohio State University. Kim, a veterinarian, is from a family that always grew grapes and made wine. (Author's collection.)

The Perennial vineyards were originally a four-acre plot of wine grapes, and today, the winery sells 80-percent estate wine from 16 acres of grapes that include Vidal Blanc, Cayuga, Chancellor, Riesling, Concord, Niagara, Delaware, Vignoles, Cabernet Franc, and Chambourcin. Some vinifera grapes are purchased from Leeman's brother at Van Ruten Winery in Lodi. The winery uses green methods in its harvesting and grape making, and even makes its plasticware from sugar and potatoes. (Courtesy of Perennial Vineyards.)

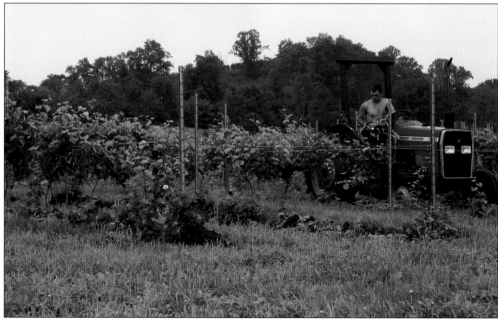

Five

THE LAKE DISTRICT

In an area dotted with wineries and vineyards, it had to be decided what constitutes a "canal country" winery. Obviously, those along the Cuyahoga River and the Ohio and Erie Canal should be included. Not so obvious was the connection of the wineries to the east, going toward Pennsylvania, and south of the Lake Erie region.

The answer came in the fact that trajectories were built from the Ohio and Erie Canal. The Pennsylvania and Ohio (P&O Canal), the Muskingum side cut, and the Mahoning Canal extended the transportation of goods and services to the southeast. These waterways were operated from 1840 until 1872 and were funded by private interests. Privately-owned canals were built until there were 1,000 miles of canals in the state of Ohio, passing through Niles, Warren and Youngstown.

This next touring area includes Trumbull and Mahoning Counties and consists of the cities of Cortland, Girard, Hubbard, Newton Falls, Niles, Warren, and Youngstown. Again, these are in an agricultural region, except for Warren and Youngstown, which are relatively urban. Bed-and-breakfasts and country inns in the area provide the comforts of home.

YOUNGSTOWN RED
ALC. 13.7% By VOL
Red Table Wine

L'uva Bella Winery in Lowellville carries juice from California and Italy, but the wine is made right in Mahoning County. The winery only offers juice when it is available. Bottles of wine can be purchased while dining in the bistro and restaurant. Wines offered include Sangiovese, Pomegranate Passion, and black Muscat. (Courtesy of L'uva Bella.)

The lack of vineyards creates a different, but not lesser experience. One can talk with knowledgeable winemakers and make new discoveries at winemaking wineries just as easily as at wineries that are also working farms. Some Ohio wineries feature wines from all over the world—but if the wine is made in Ohio, it is an Ohio wine. (Courtesy of L'uva Bella.)

In 2008, Cortland Wine Cellar opened in a large warehouse north of Cortland, where teaching about winemaking and selling homemade wine supplies was the focus. Deborah Beltz was a home winemaker for over 30 years, and when Sheila Fisher started taking winemaking classes, they learned about sourcing juice. Four years later, they found a beautiful spot near Mosquito Reserve, and their dreams came true. The J.S. Morrow property was used for horse trading in the 1800s, and many horse shoes were recovered on the property during renovation. Larry Taylor is pictured on the property in 1957 when it was used for horse trading. (Courtesy of Country Porch.)

Owners Beltz and Fisher dreamed of starting a winery where people could enjoy wine and cookouts and play games. The women took the barn apart and repurposed and reused grape carts in the bar and tables in an attempt to create a feel of old winery days in a place that was all gristmills and horse farms. All wine is made on the property from Ohio, New York, and Pennsylvania grapes. (Courtesy of Country Porch.)

Every winery should have a motto, a way to focus on what is important. At Country Porch, the motto is, "It's simple. We love our country porch & hope you will too." Wines offered include handcrafted Riesling, Catawba, blackberry blend, sangria, Niagara, Cayuga, Chambourcin, Vignoles, Corot Noir, Cabernet Franc, raspberry, and Norton, from sweet fruit wines to bold vinifera reds. One can always get dips and bread with cheese, but the special food events, with food from local sources, attract a crowd. (Courtesy of Paul Taller.)

Greene Eagle Winery, also in Cortland, makes an effort to help visitors "take a sip back in time!" The quaint winery set back from the road has a homey 18th-century feel with its post and beam architecture. The winery loves old cars, and its car-show weekends are popular with wine enthusiasts because one can wander around to see vintage cars while also sipping a glass of handcrafted wine. The winery was opened in December 2009 by Dale and Keith Bliss when they retired. The property was owned by Keith and Peggy Bliss before the winery opened. (Courtesy of Paul Taller.)

Inside the winery, the wine can be sampled for 50¢, and glasses are $5. The Fireside, Velvet Sky, and Twilight are the Cabernet Sauvignon, Pinot Noir, and Shiraz, respectively, and the two white viniferas are sweet, a Gewürztraminer and Riesling. Unusual pear kiwi, strawberry rhubarb, and chocolate strawberry also appear on the wine list. The Barolo is a nice red blend. Cheese plates, pizzas, breads with spreads, salads, sandwiches, and desserts make for great meals at the winery as the sun sets over the tree line. (Courtesy of Greene Eagle.)

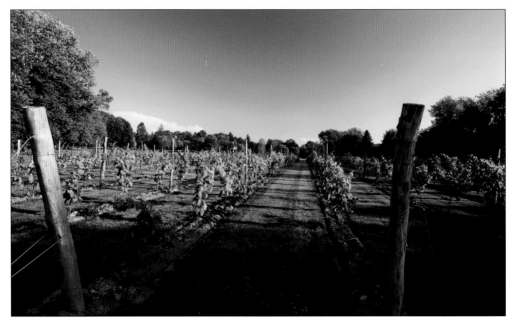

Wooster's Ohio Agricultural Research and Development Center recommended that the Mastropietros start with French-American hybrids, so they planted Chambourcin, Vidal Blanc, and Frontenac at Mastropietro Winery. A regal entrance amongst rows of vineyards greets guests as they make their way to the rambling winery, which has a Tuscan feel and is situated on a lake. (Courtesy of Paul Taller.)

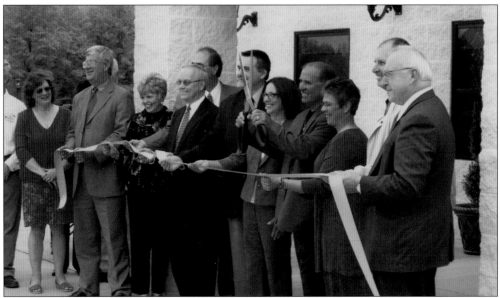

The wines at Mastropietro Winery in Berlin Center are crafted by Daniel Mastropietro, who owns the winery with Marrianne and Cathy Mastropietro. Encouraged by their success at amateur wine competitions, including the Bronze Medal for their Zinfandel in Winemaker Magazine's International Wine Competition, Daniel and his wife started to research the industry and opened a 52-acre winery near Lake Berlin and Lake Milton with a one-acre lake and thee acres of vineyards. Mastropietro Winery was founded in 2005 with this ribbon cutting. (Courtesy of Mastropietro Winery.)

Joseph Mastropietro, grandfather of the owners, produced classic red Italian wine. Daniel took up the family tradition using California Cabernet Sauvignon and Merlot grapes. True to their Italian heritage, Daniel chooses to use Old-World winemaking methods. One of the most enjoyable assets of Mastropietro Winery is the monthly volunteer potluck get-together. Volunteers bottle, harvest, and press, a common practice at wineries. The winery hosts outdoor entertainment, weather permitting. This was the first winery in Mahoning County, nestled on 14 acres between Lake Berlin and Lake Milton. (Both, courtesy of Mastropietro Winery.)

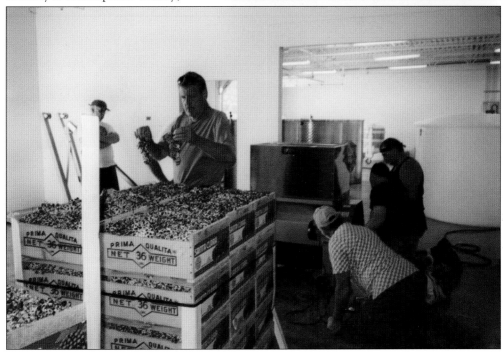

In nearby Berlin Center, on Lake Milton, Myrddin Winery's location and character are summed up with the slogan, "Wine, Water, Woods, and Wildlife." Sitting on the deck, visitors can drink wine while water shimmers through the woodland tapestry and birds chatter in the trees above. Myrddin (which means Merlin in Welsh) opened in 2004 and is owned and operated by Kristofer and Evelyn Sperry. Because the winery is on the bank of Lake Milton, it can be reached by boat. They named the winery after the god of high places. (Courtesy of Paul Taller.)

The 1990s Prairie-style house is meant to feel magical and was designed by Kristofer, an architect. The Sperrys buy and grow their own grapes, including Vidal Blanc vineyards above Lake Milton. They sharecrop Concord, Seyval Blanc, Buffalo, Syrah, Noriet, Zweigelt, and raspberries. Kristofer is the winemaker. The dry Chardonnel is easy on the palate, the Pendragon blend and the Oren, a semisweet Traminette with a hint of honey, are worth trying. Fruit wines include Igraine cranberry and Black Enchantment, a sweet black-raspberry dessert wine. (Courtesy of Paul Taller.)

Lil Paws Winery is also on Lake Milton. This area of Ohio is not just rural, it has a small-town feel, and the lake is omnipresent, just like Lake Erie is in the northern part of the state. Lake Milton Township was part of the Connecticut Western Reserve, a 120-mile-wide strip of land granted to the Connecticut colony in 1662. The 1,685-acre lake was created by damming the Mahoning River upstream in 1917. (Courtesy of Lil Paws Winery.)

The name "Lil Paws" is in keeping with the winery's naming all its wines after dogs that they have had or dogs that they have known. The four paws in their logo represent the four founders of the winery, who all make wine. The winery purchases its juice and tries to stay local. Although they had a lightly-oaked Chardonnay and a fruit-forward Shiraz in 2014, but as at any winery, the wine could be different at the next visit. Enjoy a flight of wines in a logo glass or tumbler. (Courtesy of Lil Paws Winery.)

Halliday's Winery on Lake Milton overlooks land where Jesse Halliday settled in 1804. Halliday's features six house wines (three white and three red) named after historical figures or events important to the area that was once laced with rivers and trails. Overlooking scenic Lake Milton and Olde Dutch Mill Golf Course, Halliday's Winery, owned by Ron and Mike Birchak, offers the best of what Northeast Ohio has to offer: great wine, excellent food, craft beers, and a lot of fun. The winery is named after Jesse Halliday, born in 1774, one of Ohio's first entrepreneurs—he built and owned a river-powered gristmill less than half a mile from the winery. When peace came to the wilderness, Ebeneezer Zane and Gen. Rufus Putnam led the way for the entrepreneurs, who built the roads, canals, and railroads that remain as monuments to their energy. (Both, courtesy of Halliday's Winery.)

Six

THREE RIVERS WINE TRAIL

The southernmost place for canal country wines is in Coshocton County, where the 330 area code gives way to 740 closer to the Ohio River southwest of Tuscarawas County. The five wineries in Coshocton County are known as the Three Rivers Wineries because of the confluence of the Walhonding River and the Tuscarawas River, which together form the Muskingum River. Once a heavy-duty player on the Ohio and Erie Canal, Roscoe Village, now a restored canal town, depicts what life used to be like on the edge of the civilized world in America. The first canal boat on the Ohio and Erie Canal, the *Monticello III*, docked in 1830 at Coshocton. A heritage tourist attraction, the village showcases the area's unique canal history.

Ohio's network of navigable canals, constructed between 1825 and 1847, provided a system of economical transportation where none had previously existed. The young state, with its isolated frontier economy, was transformed almost overnight, and Roscoe Village celebrates the canals that opened markets, and reminds Ohioans of their debt to those who built Ohio's first transportation system. A Mr. Shitz in Crawford Township was the only one who operated a winery in the county in the old days, according to *Coshocton County* by William R. Hunt. Yet in *History of Coshocton County, Ohio, 1881*, compiled by N.N. Hill Jr., it was noted that J.K. Johnson planted quite a large vineyard one mile east of the town, the wine being used for medicinal and church purposes, and the book noted that the number of vines were growing. Against that background, visit the unique wineries of the Three Rivers Wine Trail.

Start with Yellow Butterfly in Newcomerstown at the edge of the county, then head over and down the dirt road to Rainbow Hills before visiting Raven's Glenn, which opened the same year as Shawnee Springs, where the food in the onsite restaurant will delight. Mid-afternoon, experience Shawnee Springs' back-road hospitality, and end at Heritage, where an overnight stay can be quite charming. Wander through the streets and shops of Roscoe Village the next day.

Trundling along winding roads on the way to Yellow Butterfly Winery, look for that bit of yellow, the 100-year-old restored barn that announces arrival. The winery opened in 2009 on 45 acres. At the tasting bar, sample a variety of dry, semisweet, sweet, or fruit wines all produced on site from estate-grown grapes or those from other Ohio vineyards. Trimanette and Vidal Blanc are grown on the property. (Courtesy of Yellow Butterfly.)

The rolling fields invite wine sippers to relax and take in the view while drinking Sincerity, a semisweet white wine, or Raspberry Razzmatazz, a raspberry and apple blend. All wines are crafted by Michael White, a former Cleveland mayor who began to make wine because someone gave him a gift certificate for his birthday. He fell in love with winemaking. (Courtesy of Yellow Butterfly.)

The alpacas on the premises of Yellow Butterfly provide a hint of the depth of this winery. When Michael and JoAnn first bought the property, they started raising alpacas, and today the socks, yarn, scarves, and teddy bears made from the fiber produced by them are available in the Nook gift shop. They also started a nonprofit horse-rescue operation to rehabilitate mistreated or injured horses before adopting them out. Acknowledging the importance of interpersonal relationships, the Whites encourage escaping to their place on Wednesday evenings and suggest there are plenty of accommodations in the area. (Courtesy of Paul Taller.)

Once the sign for Rainbow Hills Vineyards is spotted on the main road in Newcomerstown, head down a gravel road that seems to be going nowhere but opens up to a meadow of brooks and a rustic sandstone and wooden tree house, flower gardens, and a fountain. Rainbow Hills Vineyards was founded by Leland C. Wyse in 1988, with vineyards planted in 1985. Leland's wife, Joy, carries on the vineyard and winery operations today. (Courtesy of Rainbow Hills.)

The Wyses lived near vineyards in Oregon and Australia, which inspired them to conjure the rocky backwoods 82-acre farm and create a 3,000-square-foot mountain retreat with a winery and bed-and-breakfast. Stones had to be removed, vines had to be planted, and the building had to be constructed. Rainbow Hills is named after the couple's shared moment of driving through a rainbow in the Australian Outback. A porch runs alongside the front of the winery, a simple building with an oak door, and a dog greets guests. Inside, the winery has slate floors and poplar and ash walls. Grapes are pressed in an oak stave with a wooden basket press and fermented in American oak or stainless steel. The winery grows Seyval Blanc, Catawba, Riesling, Cabernet Franc, and De Chaun grapes and makes wine ranging from the dry red Cabernet Franc to the sweet Rainbow Rose, a Catawba. (Both, courtesy of Coschocton County Convention and Visitors Bureau.)

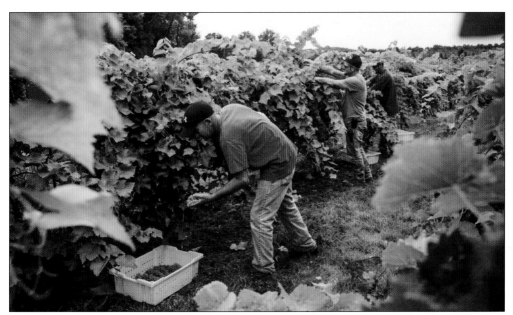

Raven's Glenn is a large sprawling winery on a main thoroughfare in West Lafayette near Coshocton situated on the Tuscarawas River. It was founded by Robert and Renee Guilliams in 2004. Former long-term care facility owners, the Guilliams love to tour wineries, and during their travels they were inspired to open their own. Their dream became a reality when they sold their business and started planting vineyards and keeping horses on 100 acres of land previously owned by Larry and Judy Korbel. Three acres of vineyards are at the winery, and 22 acres are at a separate location. The vineyards produce Vidal Blanc, Chardonel, and Noriet grapes. The Syrah, Petit Sirah, and Rosso are excellent reds. (Both, courtesy of Raven's Glenn Winery.)

The winemaker at Raven's Glenn Winery, Beau Guilliams, learned how to make wine from enologist Tony Carlucci. Guilliams creates a variety of wines, including their award-winning port-style wine. Choose to enjoy a tasting at the bar in the gift shop or eat dinner in the Italian restaurant (inspired by Robert Guilliams's Italian roots), where diners can enjoy the cuisine inside the dining room or on the river deck overlooking the Tuscarawas River. In addition to estate-grown wines, the winery offers a variety of vinifera and hybrid wines, including blends like Scarlet Raven and White October. (Both, courtesy of Raven's Glenn Winery.)

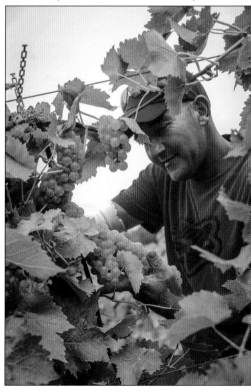

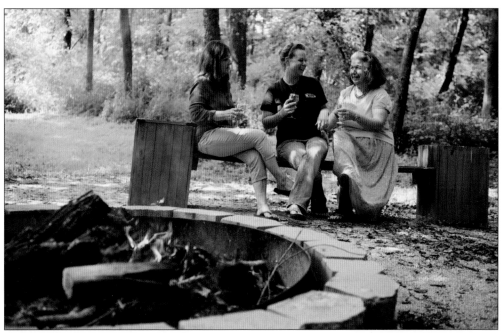

Shawnee Springs Winery in Coschocton is down a hard-to-find dirt road in the woods near the confluence of the Tuscarawas and Walhonding Rivers. Cindy and Randy Hall named their winery on 95 acres for the Shawnee Nation, who hunted on their land. Influenced by the success of Rainbow Hills, Randy and sons Jess and Benjamin cleared 2.5 acres of land and planted the new vineyard with Catawba, Niagara, and Concord grapes, known for their resistance to cold. They work hard to cultivate vigorous vines. (Both, courtesy of Coschocton County Convention and Visitors Bureau.)

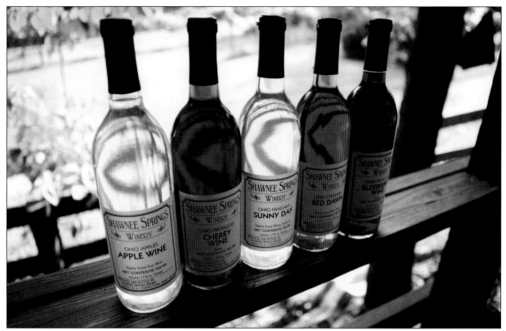

The grapes are processed in a stainless steel de-stemmer and pressed in oak, then cold stabilized at 55 degrees in stainless steel. Shawnee Springs works toward consistently well-made handcrafted wines. The tasting room is in a red barn where visitors feel the Native American spirit of the Delaware people, who hosted celebrations with the Shawnee tribe, in the furnishings and artwork. Scott Callahan, Cindy's son, oversees the day-to-day operations as general manager. The winery makes a lot of fruit wines as well as blends like Midnight Mist, Sunny Day, and Red Dawn. (Both, courtesy of Coschocton County Convention and Visitors Bureau.)

Heritage Vineyards Winery in Warsaw, near Cochocton, prides itself on offering a variety of estate-grown American and French hybrid and fruit wines crafted to please any palate. Wines include Niagara, Chambourcin, Traminette, Seyval, and vineyard peach. All wines are made from Ohio grapes. The winery is approached by driving through 10 acres of vineyards, with the dogs as greeters. (Courtesy of Paul Taller.)

Randy, Tina, Brandon, and Brent Endsley have created a relaxing place to taste wines or spend a night in the heart of the canal country region, not far from the attractions of Roscoe Village. The land was originally owned by a brother-in-law. The Endsleys were advised by Lee Wyse to put the winemaking and tasting operations all in one building while their youngest son was learning about winemaking at Rainbow Hills. (Courtesy of Coschocton County Convention and Visitors Bureau.)

The long tasting bar at Heritage is often manned by Tina, who patiently explains what makes each wine special and encourages tasters to fully experience the wines. The Heritage Vineyard guest house opened in 1999 and provides views of the vineyards and comfortable rooms. Sip the Lighthouse Red or Twilight Catawba while sitting on the wraparound porch. When spending the night, breakfast is included. (Both, courtesy of Coschocton County Convention and Visitors Bureau.)

Seven

FARM COUNTRY

Most of Ohio's Amish live in Tuscarawas and Holmes Counties, their homes easily identifiable by the clothing hanging outside on the lines, the horse-drawn buggies in the driveways, and the neat and plain appearance of the homes and farm buildings. The Amish, many of whom arrived in Ohio via Pennsylvania and were originally from Germany, believe that plain clothing and no modern conveniences encourage separation from the world in favor of a deeper relationship with God.

In the rolling hills of Ohio's northeast-central part of the state, visitors arrive in Amish country, where tens of thousands of Amish live, to purchase their crafts, buy their food products, and experience the open country roads. Recently, wineries have become part of the mix of shops and restaurants. In the Dover area southwest of Canton, start with School House Winery before getting some candy at Eiler's Candy Shop. Do not miss the congregated Breitenbach, Silver Moon, and Swiss Heritage Wineries. Breitenbach is by far the oldest and largest of the wineries, but each has unique character.

Continue on to Sugarcreek and stop at Heini's Gourmet Market or go there first and back track, stopping to shop along Route 39. Warther's Cutlery and Museum has a long history in the area. Continuing west will take you to Holmes County, but not to fret—that county also has its share of newer wineries and vineyards. Other wineries came into the region after Breitenbach's successful entrance, including Troutman, Guggisberg, and French Ridge.

Holmes and Wayne Counties are known for farming, Amish food, and cheese. Gugggisberg Cheese, Heini's Cheese House, Shisler's Cheese House, and Walnut Creek Cheese, along with Coblentz Chocolate Company, can all be found in the rolling hills of these two counties. While in the area, overnight choices include the Wooster Inn, Guggisberg Inn, the Inn at Honey Run, and Mohican State Park.

Breitenbach Wine Cellars came into being when Cynthia and Dalton "Duke" Bixler, German descendants from Sugarcreek and Bolivar, began a retail establishment in 1978 that featured cheese, meat, and produce. Duke was making wine in the cellar and converted the threshing barn into wine production. Their daughters Anita Davis and Jennifer Kohler share in the winery operations today, with Jennifer making wine. The winery is named after the waterway that crosses the 120-acre property (*breitenbach* means broad or wide stream in German). Breitenbach is most famous for dandelion wine, which is celebrated during an annual dandelion wine festival. The early wines were sweeter, but as customer tastes have changed, so have the wines. The wines win international medals and include grape and fruit wines such as Cabernet, Merlot, Sangiovese, Shiraz, Zinfandel, Sauvignon Blanc, Riesling, Viognier, and Gewürztraminer, as well as ports, sherries, and ice wines. (Both, courtesy of Breitenbach Wine Cellars.)

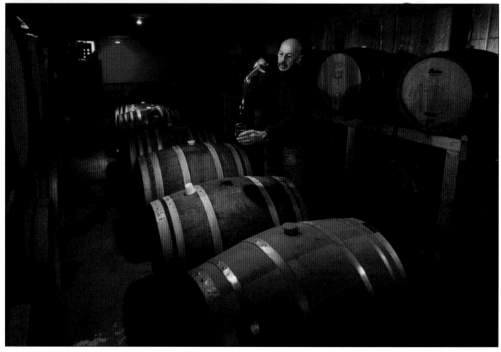

Duke Bixler uses stainless steel and American and French oak for fermenting the wine for nine to 24 months. The grapes are purchased from premier growers and harvested by hand or machine and transported to Dover, crushed on the premises, and pressed with bladder presses. The production room is expansive, attesting to how large the winery is—the beloved wine is widely distributed throughout the state of Ohio. (Courtesy of Breitenbach Cellars.)

In addition to the Roadhouse Red and Frost Fire blends, the Festival red wine won a prestigious award from the Culinary Institute of America. All wines have won medals, including their ice wine, port, and sherry, most being very fruit forward. Equipment includes a German crusher, and the red fermenter is outside. Wines ferment in French and Hungarian oak, and the art of winemaking comes in with the blending. The labeling machine can label 100 bottles a minute. Many members of the Bixler family are involved in the winery, which recently opened an amphitheater larger than the one at Blossom Music Center. (Courtesy of Paul Taller.)

Silver Moon Winery, in Dover, is near Breitenbach off Route 39. The building previously housed a church and a store but seems to have found its niche as a winery with a large gift shop. Owner Judy Eschbacher and winemaker Ken Eschbacher founded the winery in 2004 in a town that grew from a tolling station of the Erie Canal in the 1800s. In 1908, twenty-two saloons and two breweries were closed down during the heyday of the temperance movement. Ken became interested in wine in 2008 during a visit to the U-Vin Winery in Canada and now makes small batches of white and red viniferas and sweet wines like Romance Red and Kiwi Melon. No vintages here, and the favorites, like Strawberry Blonde and Razzle Dazzle, are distributed. The crisp Chardonnay, green apple Pinot Grigio, and smoky Zinfandel are good choices for tasting. (Above, courtesy of Silver Moon; below, courtesy of Paul Taller.)

Swiss Heritage Winery in Dover's Broad Run Valley started out making cheese, and many visitors to the area can remember buying cheese there while canvassing the area decades ago. It was a co-op and was known as the Cheese House, which opened in 1933. Wine goes well with cheese, and so the Swiss house started making wine that can be tasted at a small bar and high tables at the left end of a room packed with Victorian treasures and funky mementos. Nancy Schindler, part owner, is pictured here waiting to serve. (Courtesy of Swiss Heritage Winery.)

The wine, as well as the cheese, is made on the premises, behind the gift shop, by Chad Schindler. It opened in 2002 at what is now known as the Broad Run Cheese House, and is owned by Nancy Schindler and her son Chad. The winery sources its juice from Ohio (Niagara and Catawba from Debonne Vineyards) and nearby states and makes about 7,000 gallons of wine a year. The wines include labrusca, vinifera, and fruit wines, including outstanding cranberry and peach wine. (Courtesy of Swiss Heritage Winery.)

The Swiss chalet today still sells nostalgic and vintage merchandise. Every nook and cranny is filled with lace and flowers and everything is old-fashioned, just like an antique store or a grandmother's attic. They continue to sell cheese, and at the back of the store, a small seating area and tasting bar give people the chance to taste wine with cheese. A mural of 1970s-era photographs on a high wall above the tasting area portrays the cheese-making operations and announces that the business opened in 1933. (Author's collection.)

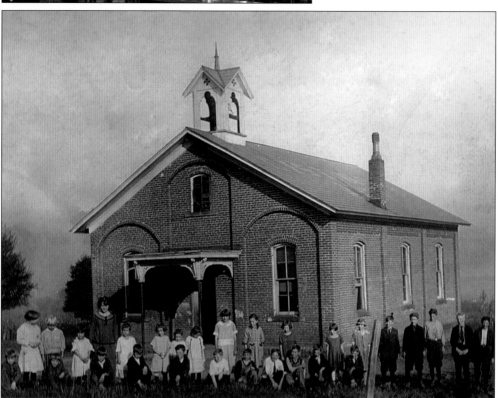

School House Winery in Dover takes the one-room schoolhouse theme to task with chalkboards and hall passes. Proprietors David and Jennifer Jagunic opened the winery in a schoolhouse built in 1886. The school closed its doors in 1941, and the building sat empty for two years before they bought it. A boutique winery, it serves dry, semidry, sweet, and fruit wines, including a lightly oaked Merlot, a dry Concord named Oak Grove (the name of the school), and Teacher's Pet, a blend of Concord and Niagara. A favorite—Bully Red, a semidry Chambourcin—is good chilled. (Courtesy of School House Winery.)

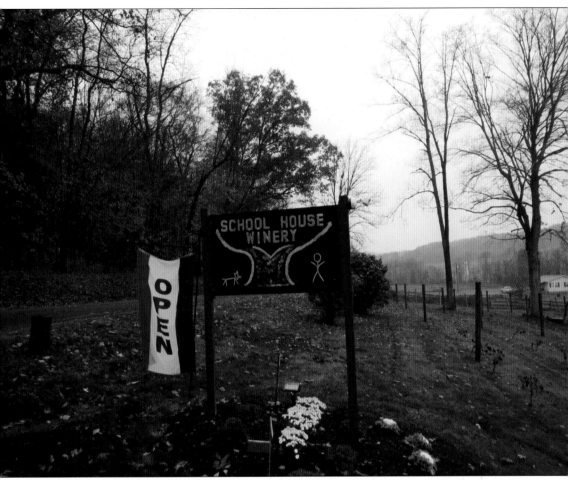

David Jagunic started making wine in his basement in 2003 and seems to like entertaining just as much as making wine. The family helps out. The wines can be paired with pizzas, a cheese plate, meatballs, or a pepperoni roll. One can relax at a table for two or bring a van full of friends. The winery makes 4,000 gallons a year on land that was part of the John Franz farm. During the summer, local bands provide entertainment. (Courtesy of Paul Taller.)

Silver Run Vineyard and Winery in Doylestown planted its vineyard in 2005, broke ground on its winery in 2008, and celebrated its grand opening in 2010. In earlier days, the Files family raised cattle on a farm where cows grazed, hay was harvested, and a hay wagon transported people from the Christmas tree field back to their cars. Husband-and-wife owners Ed Sunkin and Christine Sabo celebrate their dream-come-true of owning a winery with enthusiasm. (Courtesy of Silver Run Vineyard.)

Guggisberg Doughty Glen Winery in nearby Millersburg also began as a farm. It has expanded to include a winery and the Guggisberg Swiss Inn. Guggisberg's award-winning cheeses pair well with their wines, and the setting is breathtaking. In the winter, the inn and winery offers horse-drawn carriage rides; in the spring, the antics of newly-hatched ducks can be seen by the pond; and in the summer, horseback riding is a great pastime. This old family photo can be found on postcards at Doughty Glen. (Courtesy of Guggisberg Winery.)

The estate wines at Guggisberg range from a sweet raspberry to a drier Pinot Noir. The winery also offers Catawba, Blush, and Gewürztraminer, a traditional German wine, which fits right in with the Amish heritage in Holmes County. Their themed bottles tell parts of their story, with all wine bottles summing up their journey on the back label. One wine is named after their horse Misty, and their Laughing Blush seems to cause everyone to laugh. Eric and Julia Guggisberg opened their Swiss inn in 1993. The family has made cheese for over 50 years and is originally from Bern, Switzerland. An Amish vintner makes their wine. (Courtesy of Paul Taller.)

French Ridge Winery in Killbuck has had vineyards for many years. The secluded location in the Killbuck Valley and the hilly countryside make the location of this winery overlooking its vineyard special. When Scott and Kathy Buente first planted the vineyard in the spring of 2001, they began modestly with just two types of grapes. (Courtesy of Paul Taller.)

The winery loves to host themed benefit dinners—lobster, Caribbean, Italian, and German—and donates the proceeds to families in need. The winery considers itself to be a family-oriented destination and offers overnight cabin accommodations. French Ridge vineyards now spans 23 acres, 10,000 vines, and 11 different grape types. (Courtesy of French Ridge Winery.)

French Ridge has the largest vineyards in the tri-county area, and all the wines are made from estate-grown grapes. On opening a winery, Kathy responds, "We blame it on my mother. She always told us 'You have all this land, why don't you do something with it?' So we did!" Scott grew up on a vineyard in New York State and brought years of experience in growing grapes. Owning and operating his own vineyard was a dream of his, and his passion spread to Kathy quickly. She recalls thinking, "We are putting in the work, why not enjoy the fruits of our labor?" (Courtesy of French Ridge Winery.)

Deanna and Andy Troutman opened Troutman Vineyards in Wayne County in 1998. The Troutmans, who are avid lovers of agriculture and farm products, met at Ohio State University. She was in marketing, and he was a Lonz Winery Fellow with a degree in agriculture. They bought the farm outside Wooster in 1997 and renovated the old farmhouse, enlivening it with gardens and flowers, and turned the chicken coop into a winery. Farm animals have the run of the barn and surrounding pasture, like any small winery. (Courtesy of the Troutman family.)

Wooster is known as prime agricultural land, and the Cabernet Franc, Vidal Blanc, Chardonnay, and Chambourcin grapes grown in the vineyards enhance the area's reputation. The Troutmans use a membrane-basket press. The wines are held in stainless steel for six to eight months, with the exception of the Cabernet Franc, which ages in oak barrels. The winery also makes a Chambourcin ice wine and Red Menagerie Chambourcin as well as White Menagerie Seyval Blanc. (Courtesy of the Troutman family.)

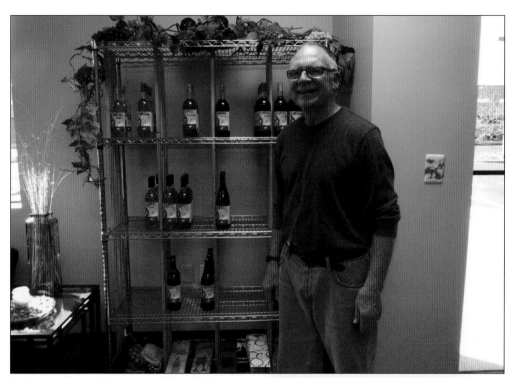

In the northwestern corner of Canal Country, just south of the Lake Erie Region, this wine journey has made a circle around Northeast Ohio, possibly stopping in Medina County on the way. It's Your Winery warehouse was perched on a hill in Akron overlooking a major thoroughfare until it moved to its present location in 2014. The winery offers over 50 varieties of wine—everyone can find a wine they enjoy and can make from kits at home. From Yakima Valley Pinot Gris to Lodi Old Zinfandel, the typical yield from a kit is about 30 bottles of wine. Price includes corks and personal labels. (Courtesy of Paul Taller.)

While the winery does not grow grapes and does not utilize Ohio grapes, It's Your Winery qualifies as a winery because it makes wine. The advantage to having juice brought in is the variety—the list includes a white Merlot blush, Gewürztraminer, blueberry Pinot Noir, and Amarone, typically made from partially dried Corvina and Rondinella grapes. The urban winery is a place where one can saddle up to the Barrel Bar to enjoy wine while talking with Dave Foltz, who owns the winery with his wife, Kathy. (Courtesy of Paul Taller.)

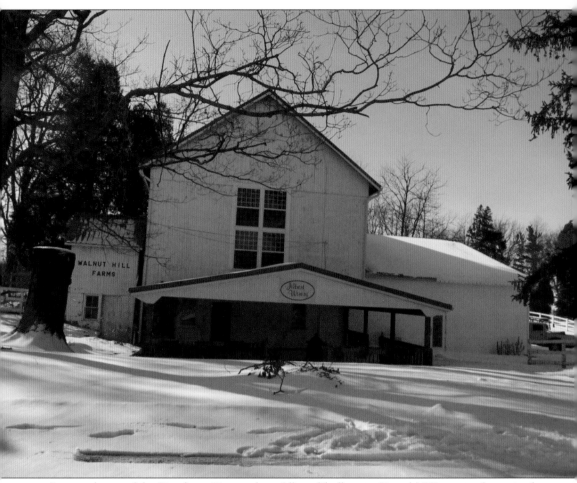

Just southwest of the Cuyahoga County line, Jilbert (Jhelbare in French) Winery is almost in the Lake Erie Appellation, and was, in fact, included in *Ohio's Lake Erie Wineries*. The picturesque 1905 dairy farm sitting on wooded land just off a winding road in Valley City was purchased by Lisa and Dave Jilbert in 1999 and became the first pure meadery in Ohio. It now also sells grape wines in addition to honey wines. An old carriage house has become the honey house, where wildflower honey from beehives on the farm and nearby properties is hand harvested by Dave and made year-round. (Author's collection.)

Eight

CANAL COUNTRY WINERIES THEN AND NOW

Ohio's canal country vineyards and wineries are a new way to use the abundant and fertile farmland south of Cleveland in northeast Ohio. There is no doubt that early homesteading, the development of communities along the Ohio and Erie Canal and its tributaries, industries that made use of the Canal and later, the railroad, and the burgeoning wine industry on Lake Erie's shores and islands influenced today's viticulturists and enologists.

Whether the winery grows its own grapes, uses grapes from Ohio, or brings in juice from other places, each winemaker and winery owner has a passion for good wine, bringing people together, and creating a place that people can enjoy. Some of the wineries solely focus on the wine, some provide meals, and others engage their customers with entertainment or art. The canal country wineries are rarely empty, and by providing a place where people can enjoy locally-crafted wine, the wineries pay tribute to the wine pioneers of the Lake Erie and Ohio River Valley regions that went before them.

They have had much help. Whether they learned from others in the industry, their neighbors, age-old European enologists, or from modern-day facilities engaged in education like the Ohio Agricultural Research Center and the Ohio Wine Producers Association, they approach the process of making wine with unique fortitude. It is not easy to turn grapes into wine.

And for viticulturists, or grape growers, growing grapes away from the moderating effects of Lake Erie, the vines have to be winter-hardy and the grapes made to withstand low temperatures. A lot of money is at stake in this risky business. The choice of grapes is not an easy one either.

Traveling by flatboat down the Ohio River or by horse and wagon over the Appalachian Mountains, pioneers built settlements and planted crops, including orchards and vineyards. In 1813, Nicholas Longworth, around Cincinnati, laid the foundation with champagne and still wines from the Catawba grape. During the heyday of Ohio wine in the 1850s, Cincinnati and its environs were the center of American wine production. These Catawba grapes are growing at Mon Ami Winery in Port Clinton. (Author's collection.)

Ohio is in the midst of a grape-growing, winemaking revival, and its wines are winning competitions on a national level. East of Cleveland, Ashtabula County has more wineries per square mile than any other region of the state and is home to over half of the wine grape acreage in Ohio. To the west of Cleveland, the wineries of the Lake Erie Islands are fondly remembered by generations of Ohioans who vacation on the lake. Now, one can enjoy wineries all around the state. (Author's collection.)

The Lake Erie region gained prominence in 1869 and became Ohio's new wine capital. Adulteration of wine and competition caused a decline in Ohio's winemaking in the 1880s. Prior to that, Ohio viticulturists could compete with the best in France. In the late 1920s, when the temperance movement was hot to eliminate consumption, a surplus of grapes caused many vineyards to close, and many wineries grew Concord grapes for Welch's. The Lake Erie Islands Museum's displays and video put this in perspective. (Author's collection.)

Ohio wines are going mainstream as people discover the many varieties and that Ohio's wines are not all sweet. When combined with the booming culinary scene and chefs in the Cleveland area, it is not surprising that Pairings, the Ohio Wine and Culinary Center, opened in June 2014. Pairings has easy access to Geneva State Park and stages wine classes, educational tastings, and culinary events for the public. (Author's collection.)

YOUR GUIDE TO
CANAL COUNTRY WINERIES

The facing page features a map of the Canal Country wineries included in this book. However, as of the time of publication, some wineries not featured in these pages have emerged and at least one has closed. The winemaking institutions included in this volume were established as of January 2015, and have been listed (with their corresponding numbers) below.

Chapter Two: The Cuyahoga Valley

28	Red Horse Winery
29	Sarah's Vineyard
41	The Winery of Wolf Creek

Chapter Three: Foothills of the Appalachians

1	Al-Bi Winery Co.
2	Barrel Run Crossing Winery and Vineyard
4	Cana Valley Winery
5	Candlelight Winery
7	Crafted Artisan Meadery
10	Grape and Granary
17	Laleure Vineyards
18	LaPorte Winery
36	Thorncreek Winery
38	Twigg Winery
39	Viking Vineyards

Chapter Four: Stark County Canal Towns

9	Gervasi Vineyard & Italian Bistro
20	Maize Valley Market and Winery
22	Meniru Meadery
24	Newman Creek Cellars
25	Perennial Vineyards
34	Slutz & Slutz Winery
40	Vino Fabbricanti

Chapter Five: The Lake District

6	Country Porch Winery
11	Greene Eagle Winery
13	Halliday's Winery
16	L'uva Bella Winery
19	Lil Paws Winery
21	Mastropietro Winery
23	Myrddin Winery

Chapter Six: Three Rivers Wine Trail

26	Rainbow Hills
27	Raven's Glenn
31	Shawnee Springs
42	Yellow Butterfly

Chapter Seven: Farm Country

3	Breitenbach Wine Cellars
8	French Ridge Winery
12	Guggisberg Doughty Glen Winery
14	It's Your Winery
15	Jilbert Winery
30	School House Winery
32	Silver Moon
33	Silver Run Vineyard and Winery
35	Swiss Heritage Wineries
37	Troutman Vineyards

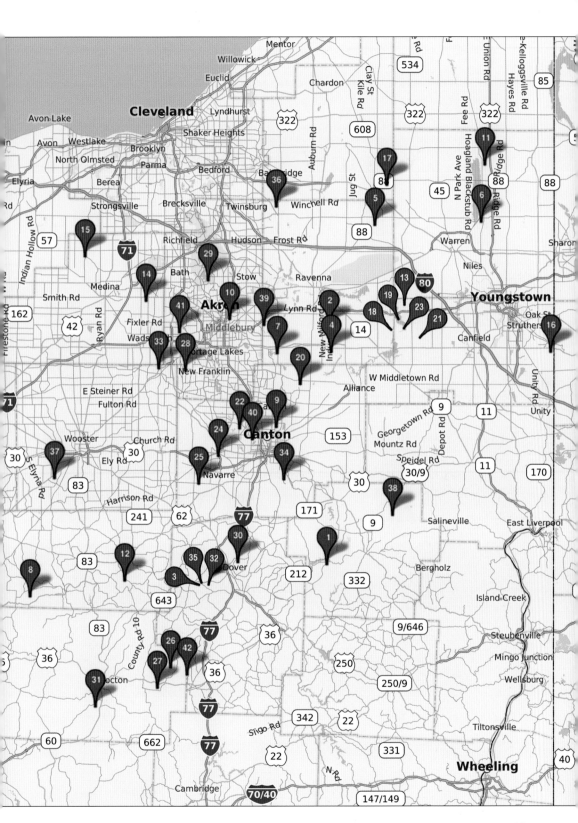

DISCOVER THOUSANDS OF LOCAL HISTORY BOOKS
FEATURING MILLIONS OF VINTAGE IMAGES

Arcadia Publishing, the leading local history publisher in the United States, is committed to making history accessible and meaningful through publishing books that celebrate and preserve the heritage of America's people and places.

Find more books like this at
www.arcadiapublishing.com

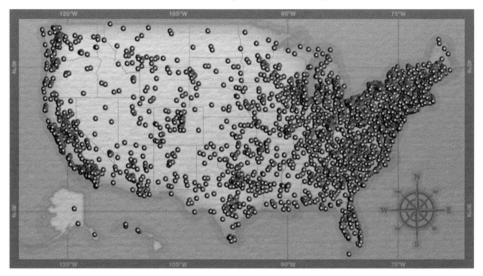

Search for your hometown history, your old stomping grounds, and even your favorite sports team.

Consistent with our mission to preserve history on a local level, this book was printed in South Carolina on American-made paper and manufactured entirely in the United States. Products carrying the accredited Forest Stewardship Council (FSC) label are printed on 100 percent FSC-certified paper.

MADE IN THE